Expressing the
Visual Language
of the
Landscape

Edited by Jennifer King
Senior Editor Terri Dodd
Designed by Vincent Miller
Typeset by Ilse Holloway

ISBN 1-929834-16-0

Printed in Hong Kong
First printed in hardcover 2002
06 05 04 03 02 6 5 4 3 2 1

Distributed to the trade and art markets
in North America by:
North Light Books,
an imprint of F&W Publications, Inc
4700 East Galbraith Road
Cincinnati, OH 45236
(800) 289-0963

On the Cover (top to bottom, left to right):

Alan Flattmann demonstrating on location; "Sedona Sunrise"
by Betsy Dillard Stroud; "St. Louis Cathedral at Dusk"
by Alan Flattmann; "Point Lobos" by Gabor Svagrik;
"September's Gold", by Matt Smith; Timothy R Thies at work
in his studio; "Harrington Sound" by James Toogood;
Steve Rogers painting in watercolor; "White Ranch Park,
Golden, Colorado" by Nikolo Balkanski

ACKNOWLEDGMENT

I would like to thank the supremely talented artists without whom this book could never have come about: Nikolo Balkanski, Gerald Brommer, DeLoyht-Arendt, Alan Flattmann, Skip Lawrence, Lynn McLain, Ed Mell, Dean Mitchell, Joyce Pike, John Pototschnik, Stephen Quiller, Steve Rogers, John Salminen, Jean Sampson, Matt Smith, Betsy Dillard Stroud, Gabor Svagrik, Timothy R Thies, James Toogood and Xiaogang Zhu. Their generosity of spirit is humbling.

Vincent Miller
Editor in-Chief/Publisher
International Artist magazine

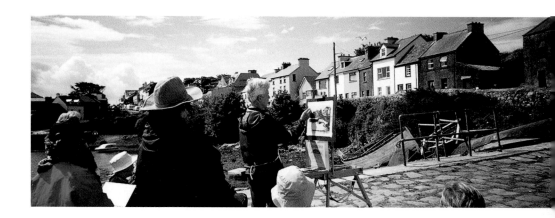

PREFACE

No matter where we go, we are often captivated by heart-stopping sights that would make excellent landscape subjects. It may be a ray of light streaming down between city skyscrapers or white, puffy clouds drifting across a wide-open cornfield or the dazzling color of the flowers in our own backyard. All of these touch our hearts and engage our creativity.

Yet when we set out to paint these subjects, we're faced with the same challenges — can we improve our design somehow, are the values correct and how can we mix the perfect colors to capture the mood we're after? That's what prompted us to put this book together.

We began by contacting just a few of the finest landscape artists we know. Then we asked each one to explain some aspect of landscape painting that they particularly enjoy, everything from design to color to detail. Along the way, we asked Betsy Dillard Stroud to put landscape painting itself into context. The final result is a compendium of brilliant insights and concrete advice — not to mention page after page of gorgeous paintings — that are guaranteed to motivate and educate, no matter what your chosen medium or style. We hope you relish reading it as much as we've benefited from working with these artists to create it. We've learned so much, and we're sure you will, too.

Enjoy! Then pack this book in with your painting gear and get out there and paint! Our world is calling us to continue the rich tradition of landscape painting.

Jennifer King
Jennifer King is the US Editor of *International Artist* magazine.

TABLE OF CONTENTS

JOHN POTOTSCHNIK

THE LANGUAGE OF LANDSCAPES

If you want to express yourself through landscape paintings, begin by ensuring your work speaks the same language as your audience. As John Pototschnik explains, communication is far more effective when you use the six universal principles of art.

Let me start with a quote from an unknown author that's had a profound effect on the way I view art: "It's all very well to say 'express yourself', but if that expression is inadequate or unintelligible to the average man, if it's unable to quicken and inspire his mind to some degree, is it really worthwhile? The great artist does not dwell alone in an ivory tower, communing with his own spirit and those choice few who may understand and value him. He goes into the highways and byways of life, meets his fellow man, and through the medium of his art, shares with them his gift and the spiritual uplift that results from it".

This statement perfectly expresses my belief that at the heart of being an artist should be an awareness that painting is a form of communication. And for me, communicating through the genre of landscape is most definitely a worthwhile pursuit. It's a subject that everyone can identify with and understand. Additionally, the diversity of the land reflects the rich array of moods and emotions I wish to express. However, in order to be truly effective in my quest to uplift my viewers with my art, I have to be clear about my message. Just as in verbal communication, visual communication requires a language or vocabulary that connects the "speaker" with the "listener", or in this case, the artist with the viewer.

So how do I make myself heard through my landscapes? Since I'm the

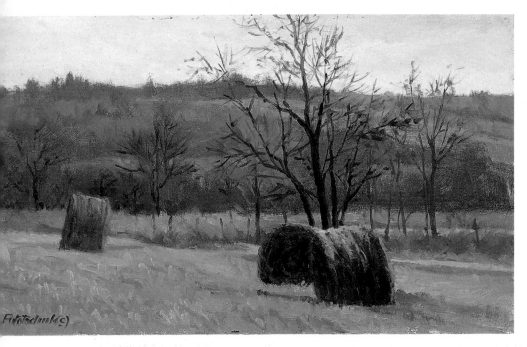

"BACK PASTURE", OIL, 9½ x 16" (25 x 41CM)
In a painting such as this, which is basically monochromatic, accurate values are a must. Temperature changes in the color add greatly to the truthfulness of the painting.

"GOLDEN SILENCE", OIL, 12 x 20" (31 x 51CM)
Appropriate color harmonies are critical to effectively depicting a setting sun.
Attention to the source of light and its color sets the tone for everything else.

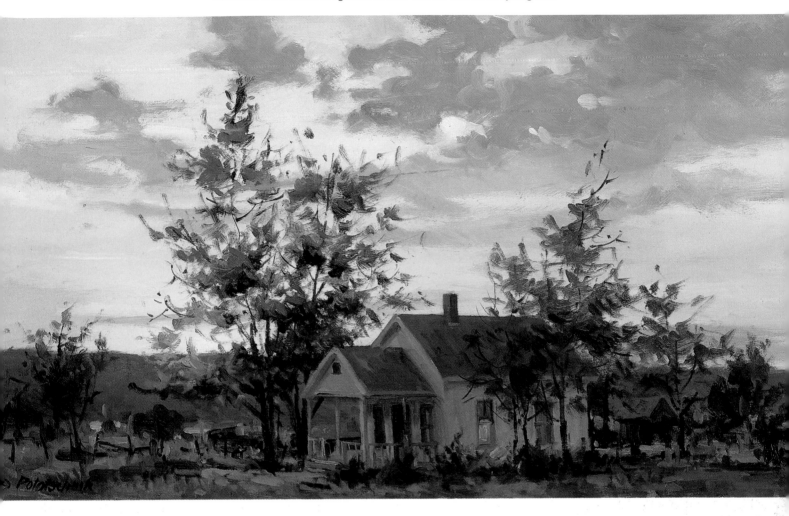

6 KEY PRINCIPLES OF ART

Through years of hard work and diligent practice, I've found that there are six fundamental principles that make up
an effective painting:

1 THE CONCEPT Once you've determined what you want to say, make sure the design, shapes, proportions, values and color of your painting are consistent with your purpose.

2 THE COMPOSITION An organized arrangement of shapes gives the painting an order for the viewer to follow.

3 DRAWING A clear understanding of proportion and perspective is the foundation for every successful painting.

4 VALUES The organization of the lights and darks give volume, depth and dimension to your paintings.

5 COLOR Color should enhance, reinforce and deepen the emotion of what you're trying to say.

6 TECHNIQUE The way the paint is applied is important but should not be an end in itself. Over time, your technique will become your signature style.

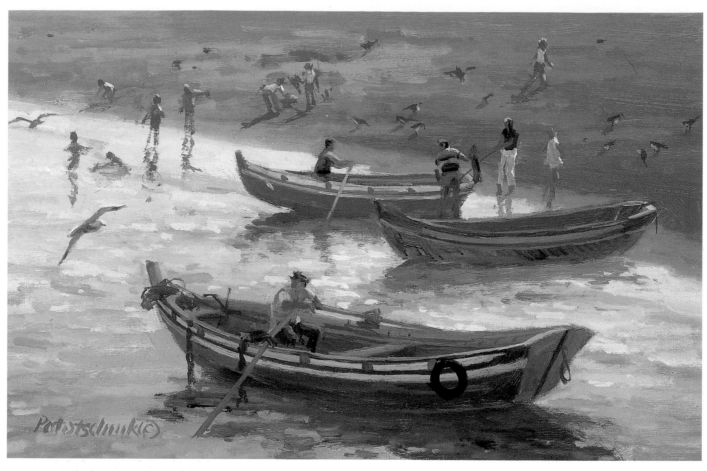

"Boats of Cascais", oil, 7 x 11" (18 x 28cm)
I often will select only specific sections of the color wheel if I believe the colors selected will be sufficient to capture the mood
I want. In this case, I used blue-green, blue, blue-violet and their complements of red-orange, orange and yellow-orange.

one initiating the "conversation", I feel I have a responsibility to my viewers to use the visual language that is universally accepted and understood by all. It follows that the more extensive my vocabulary and the better my understanding of the structure of this visual language, the more expressive and creative I can be in communicating what I want to say.

So what is this language? What are the "words" I use in my landscapes? What are the criteria for true works of art? They're the basic, time-tested principles of art.

Art is like architecture
I like to compare the principles of art to the construction of a house. This analogy provides an effective visual picture of those principles that form the fundamental foundation of every successful painting.

1. The concept, or type of house
If I were to build a house from scratch, I would start with a basic concept about what kind of house I wanted to build. Would it be French Provincial, Victorian or Contemporary? It's the same with painting — first I must develop a concept about what I want to say. Whatever I choose, I make sure the design, shapes, proportions, values and color are consistent with my purpose.

2. Composition, or floor plan
Once I've decided what I want to say and how I'm going to say it, I have to organize the space I'm working in. Just as a house needs a good floor plan, a painting needs a good composition or arrangement of shapes. Otherwise, poor organization will stop my great idea from having the desired effect. The painting will be uncomfortable to live with and may end up confusing viewers. It's just like this article — if it didn't have a logical order to it, you'd probably walk away saying, "Forget it. He's not making sense". A painting needs order, an organized composition.

3. Drawing, or the foundation
Having a clear understanding of proportion and perspective is foundational. I can have a beautiful design, wonderful color and a fabulous décor, but if the drawing underneath those factors lacks understanding, the work will collapse. Good drawing skills are essential. Using a projector is not drawing.

(continued on page 12)

8

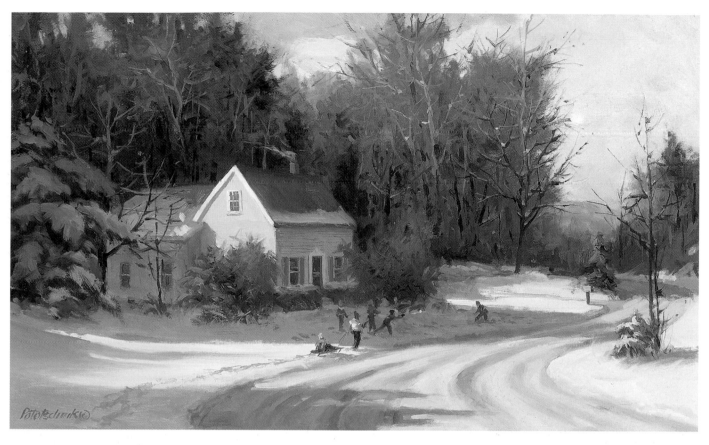

"WINTER'S GREAT MOMENTS",
OIL, 12 x 20" (31 x 51CM)
What surprised me most when doing this painting is that the light on the house required a pure yellow-green hue. I didn't expect that.

"AN AUTUMN MORNING",
OIL, 10 x 10" (26 x 26CM)
This painting is all about mood. The subtle haze enveloping everything was achieved through careful attention to values and grayed color as the landscape recedes.

ART IN THE MAKING
LIVING THE SIX PRINCIPLES

Although I sometimes finish a painting in one session on location, I developed this painting in two separate stages. First, I photographed the scene and painted an on-site study to use as references. Later, in the studio, I completed the final painting. This gave me the time to reflect on my work-in-progress while applying the principles of art and creating the best work possible.

1 CAPTURING THE MOMENT
The tranquility of this place was almost palpable. Only the sound of the wind and insects penetrated the stillness. These things, plus the atmospheric perspective, drew me to the scene and became the concept I wished to convey. After considering several possible viewpoints, I decided this view offered the most interesting composition of shapes, so I shot this photograph for later use as a reference.

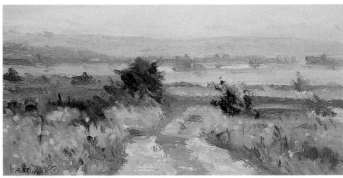

2 RECORDING IN PAINT
As always, I began doing my on-location study on a small piece of gessoed paper — in this case, a 3¾ x 7½" (9 x 19cm) sketch on a 5½ x 8½" (14 x 21cm) piece of paper. I prefer this small size because they're easy to transport, adjustable in scale, dry quickly and seldom take more than an hour to complete. I file these studies in three-ring binders for further reference, and have accumulated several hundreds of them. The main purpose of this study was to generally map out my shapes, values and colors.

TRUE COLORS

Many people are amazed to learn that I use a three-color palette — Ultramarine Blue, Alizarin Crimson and Cadmium Yellow Pale, plus Titanium White. From these three primaries, I can mix intermediary and tertiary colors, which I usually put in tubes to simplify the color-mixing process. From here, I can choose to work with any portion of the color wheel, often using triad and quadratic color combinations, depending on the mood I'm after.

My limited palette has two important benefits: First, I find the challenge both rewarding and exciting. And second, in every case my very restricted palette greatly aids in achieving color harmony.

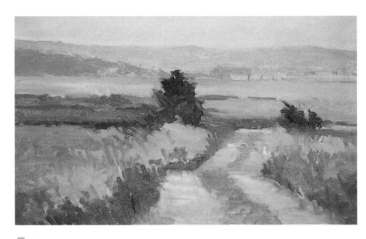

5 DEVELOPING RELATIONSHIPS
At this point, I was still referring only to the field study. My objective was to get the panel completely covered and bring it up to the level of the study before referring to the slide for detail. At the same time, I was trying to achieve the correct color and value relationships.

WHAT THE ARTIST USED

My friend Bob Tommey introduced me to his three-color palette years ago, and it's pretty much revolutionized how I use color. I experiment with other colors from time to time but my basic palette of Titanium White, Ultramarine Bluc, Alizarin Crimson and Cadmium Yellow Pale remains.

As my supports, I use Masonite panels, sanded and gessoed for all small paintings. For works larger than 18 x 24" (46 x 61cm), I use acrylic-primed linen. My materials are all professional-grade oil paints, and I prefer Liquin as my medium. I use flat brushes in Nos. 2 through 10. To finish, I varnish for protection and appearance.

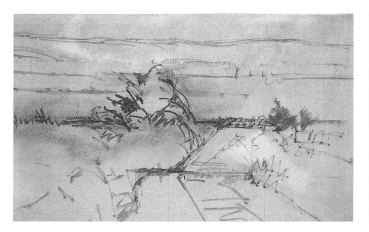

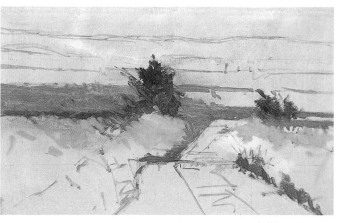

3 TRANSFERRING MY DRAWING

To prepare my Masonite panel, I cut it to 12 x 20" (31 x 51cm) (an appropriate proportion for this panoramic scene), sanded it and then applied three coats of white acrylic gesso. Then I mixed the three primaries of my palette into a color similar to Yellow Ochre, which I rubbed onto the panel. After re-proportioning the sketch to the 12 x 20" (31 x 51cm) size, I drew a simple grid over both the sketch and the panel to aid in accurately placing all of the elements. I drew in the composition with a small bristle brush, using a diluted mixture of the same Yellow Ochre paint.

4 SETTING MY VALUE RANGE

Again, mixing up various combinations of my three primary colors plus white, I started to block in my main shapes. I began at the focal point, establishing the darkest darks first.

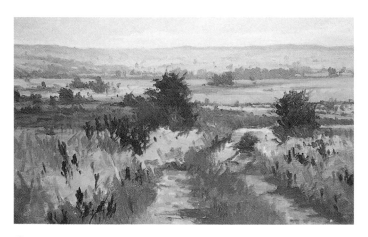

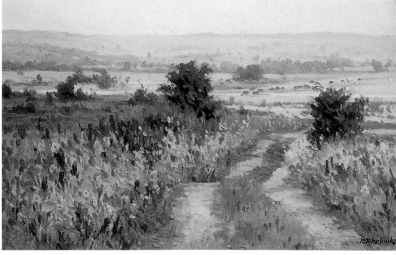

6 WORKING BACK TO FRONT

After letting the block-in dry a little overnight, I began working background to foreground, refining the colors and values and adding detail to each part as I went. I referred to the slide for information, yet I always remained conscious of maintaining the value relationships of the original study and block-in.

7 ADDING SHADOWS AND DETAIL

After blending in some deeper values to suggest shadows in the fields, I gave more definition and detail to the yellow flowers. To complete **"Tranquil Road" (oil, 12 x 20" or 31 x 51cm)**, I added a few more shadows to the tree forms in the middle ground.

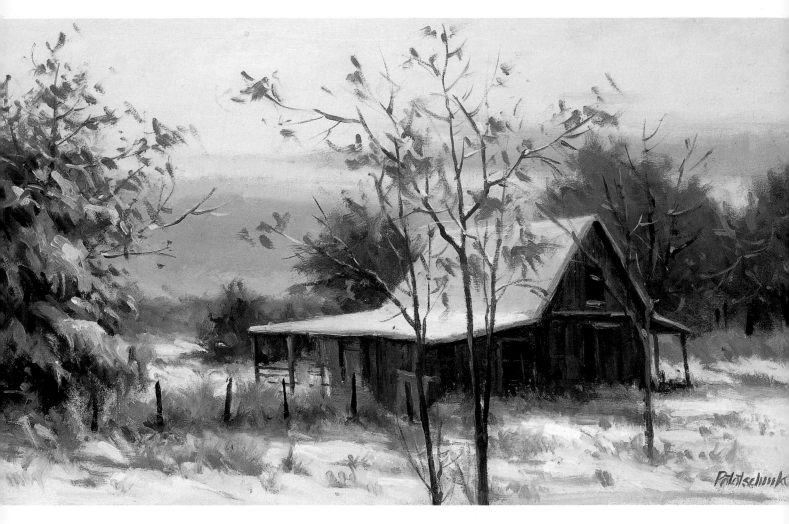

"After a Snow",
oil, 9½ x 16" (24 x 41cm)
What we want to communicate to the viewer is so important and is our responsibility. My reference photo of an old barn, used for this painting, was taken in summertime. The surrounding landscape was created from imagination.

4. Values, or the walls

By values, I mean the organization of the lights and darks in my work. Values give volume, depth and dimension to my paintings, just as putting up the walls in my house do the same.

A touch of finesse

At this point, I have everything I need for a great painting — a four-cornered structure built on concept, composition, drawing and values. There are many fine examples throughout history of complete paintings with just these four qualities, such as Frederic Remington's wonderful black-and-white paintings. Then again, I can continue on with two more principles that bring even more character to my creations.

5. Color, or the brick, siding, roof, trim and paint

Color — from realistic to exaggerated — should enhance, reinforce and deepen the emotion of what I'm trying to say. Since every color falls somewhere on the gray scale from white to black, it's important that the value patterns created earlier aren't lost and that the colors chosen are appropriate for communicating my original idea. Color, to me, should not be the only consideration.

6. Technique, or interior decorating

Technique should be thought of as the finishing touches on the house, what makes your house your home. I think it's a mistake to be overly focused on technique — the way the paint is applied

can become an end in itself. This, to me, is putting the cart before the horse. I wouldn't decorate a house before it's built, so there's no reason to seek a style of painting before I've learned the language of painting. It will happen naturally anyway. Just as my signature has changed and matured as I've signed my name hundreds of times, so has my style changed and matured as I've done hundreds of paintings.

Look outside yourself

Ultimately, landscape painting should not be so much about the artist but about others. Before I begin a new painting, I ask, "What do I want to communicate in this landscape and how can I best get it across to others so they can understand it?" With this in mind, my job is to pursue the goal of perfecting my visual communication skills and increasing my vocabulary and knowledge of the language of art.

I know of no way to do this apart from much self-discipline and training. Oh, I could take more classes and read lots of books, but it still takes a lot of "learning it for yourself". Like you and many other artists I've met, I wish I knew more, wish I were a better painter, wish I could grow faster — it's the cry of every serious artist. But all we can do is continue to work hard, strive for excellence and attempt to make our message so clear, so truthful, so exceptionally crafted that the sheer quality of our vision and presentation will scream to be noticed. □

**"MORNING FOG",
OIL, 8 x 10" (20 x 26CM)**
Knowledge of aerial perspective and its principles is important to creating a sense of depth in a painting. In the case of fog, the principles are exaggerated. Darker values and details will appear only in the nearest objects. Color will gray, details blur and values lighten rapidly as objects recede and eventually disappear completely.

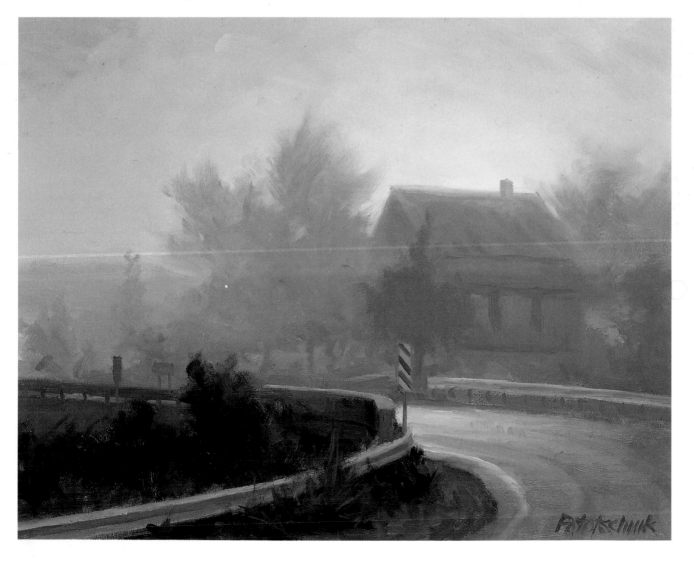

MATT SMITH

SIMPLIFICATION THROUGH MASSING

Nature offers such an abundance of information that an artist can easily be overwhelmed. Learn how to simplify subjects by seeing the big shapes — the foundation of good design — with Matt Smith.

"RED MOUNTAIN CREEK", OIL, 10 x 12" (26 x 31CM)
It is both color and value that help identify the masses in this plein-air painting. You can see how the red willow separates from the green pine trees, and how the dark value of the pines separate them from the lighter value of the snow. Notice also how the soft edge on the top of the willow gives them an organic, natural look, while the hard edge of the distant snow-capped peaks against the sky gives them a sculpted, weighted feeling.

In my mind, there are three basic components to work with in creating strong paintings — the subject, the artist's sensitivity to the subject and craftsmanship. Subject is self-explanatory. Sensitivity includes the artist's understanding and emotional connection to the subject. Craftsmanship includes the fundamentals of drawing, value, design, edges, color and mastery of the chosen medium. Orchestrating all of these components can take painting to its highest level.

Design is critical to the success of any painting, and simplification through massing is especially essential when it comes to design. By this I mean seeing the subject in terms of big shapes and arranging them in an interesting way. Along with proper drawing, color and value, an understructure of large shapes forms the foundation of a painting. A strong design has to be there prior to the detail. Handled correctly, the relationships of the big shapes give a painting the presence that makes it read well from a distance, prompting the viewer to take a closer look. Over the years, I've learned to see and simplify the basic shapes in my subjects so I can effectively translate them into my paintings' designs.

Identifying the big shapes

When painting on location, I can easily get overwhelmed by the amount of information in front of me. There can be

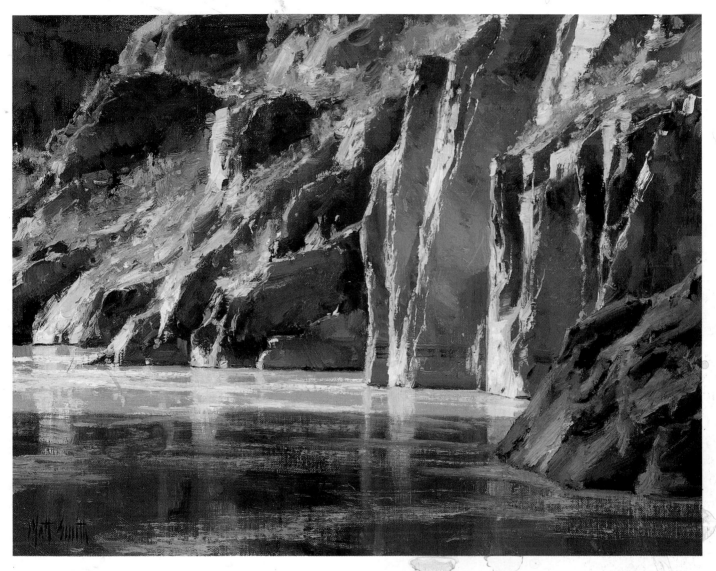

**"THE INNER GORGE",
OIL, 14 x 18" (36 x 46CM)**
This represents a more complex subject for me than most. If you study this painting closely, you will see that the strong highlights attempt to fracture the masses. However, the main masses can still be found in the dominant shadow areas.

PRELIMINARY SKETCHING

Sketching out the big shapes in a scene can be very useful. Even now, I do quick thumbnails to map out big shapes when I'm working on a more involved studio painting. If I'm painting outside, though, I want to move ahead quickly due to changing light conditions. I'm willing to adjust the shapes as I go or wipe off and start again if I'm not happy with the design. For beginners, I think it's a good idea to do thumbnail sketches before getting started. Then, as you progress, you can choose whether to continue with this step. I recommend it as a valuable tool.

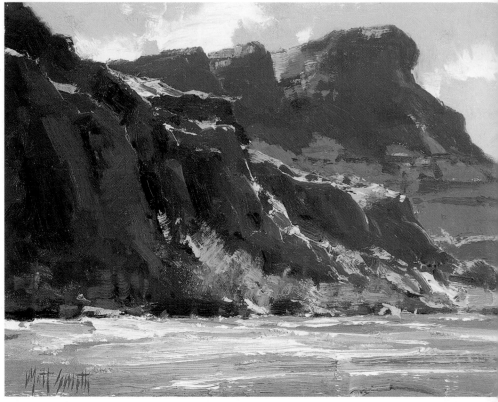

"View from Paria Beach",
oil, 8 x 10" (20 x 26cm)
Five masses are clearly visible in this plein-air painting. Although there are several contrasting highlights in the main cliff mass in the foreground which is shadowed, it still holds together. Notice how the close color and value variations within each shape are kept subtle so as not to fracture the masses.

literally thousands of bushes, trees, rocks and more vying for attention. While all of this information may be intriguing, it won't necessarily contribute to a good painting. It is at this point that I begin "editing", deciding what to leave out as well as what to include.

First I evaluate the overall scene to make sure the big shapes can be identified, then I organize them into an interesting structure. Specifically, I try to visualize and break down the scene into three to five main shapes or masses. Detail is secondary to these shapes so I look past it.

To find these shapes, I squint frequently while viewing the subject and try to pick up on any kind of contrast that might separate one mass from another. It might be a value contrast, an obvious color contrast or a more subtle temperature contrast. I ignore the "lines" or edges of the objects and pay attention to the places where one mass meets another or one plane overlaps another. I trust my eyes and the process of

squinting to reveal the shapes.

Because I group the similar areas in my scene by value or color and not according to the objects themselves, each resulting shape can include parts of several objects. For example, if there's a big contrast between the light side and the dark side of an object, the two sides each become part of two separate masses. At the same time, several smaller objects may make up one shape. This is what massing is all about.

Blocking in the masses
Once I've visualized my three to five shapes, I get started on the canvas by loosely defining them with a simple line drawing. I make one final check to ensure an interesting variety in the sizes and configurations of these shapes before developing the painting. By now I've locked in on them, so I stick with them until finished. This ensures a basis for a strong design, or foundation, for the details as I proceed.

Once the drawing is complete, I begin to average the color and value shifts within each mass and paint them as simply as possible. As I go, I decide whether color or value dominates each mass. If color is dominant, I use a narrower value range. If value dominates, I neutralize color. When all of the shapes are blocked in, I can compare them back and forth and decide whether the color and value relationships are in tune.

Turning shape back into form
At this point, the painting looks fairly flat, so from here on out I work toward restoring a sense of form, volume and depth to make it appear three-dimensional. The answer lies in understanding and then modeling form. I start by looking for important elements that need modeling, then categorizing them as one of four basic, two-dimensional types: circle, square, rectangle or triangle. I then proceed to
(continued on page 20)

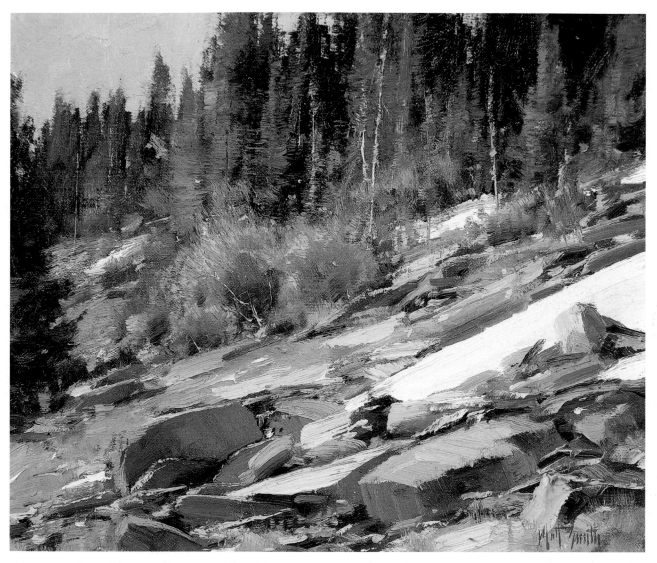

"THE LAST SNOW", OIL, 10 x 12" (26 x 31CM)
This plein-air painting is a good example of how you can have plenty of detail while maintaining obvious masses. Even though you can see numerous individual rocks in the foreground and a variety of light and shadow areas, the mass still holds together.

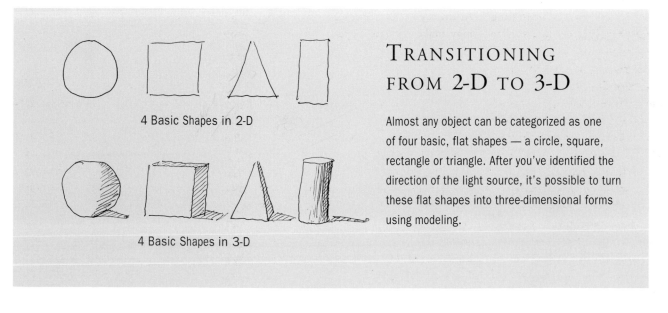

4 Basic Shapes in 2-D

4 Basic Shapes in 3-D

TRANSITIONING FROM 2-D TO 3-D

Almost any object can be categorized as one of four basic, flat shapes — a circle, square, rectangle or triangle. After you've identified the direction of the light source, it's possible to turn these flat shapes into three-dimensional forms using modeling.

ART IN THE MAKING
WORKING WITH SHAPE AND FORM

This demo piece, titled "Harding Rapids", is one of many plein-air paintings I completed while on a river rafting trip through the Grand Canyon. As you can imagine, a subject like this can be overwhelming due to its size and complexity. Simplifying the scene into a series of basic shapes helped me keep it organized and ultimately gave the painting more presence.

WHAT THE ARTIST USED

BRUSHES Hog bristle flats, No. 6

SURFACE Oil-primed linen panel

PALETTE

Titanium White
Cadmium Yellow Lemon
Cadmium Yellow Medium
Yellow Ochre
Cadmium Orange

Alizarin Crimson
Burnt Sienna
Cobalt Blue Pale
Ultramarine Blue Deep
Viridian

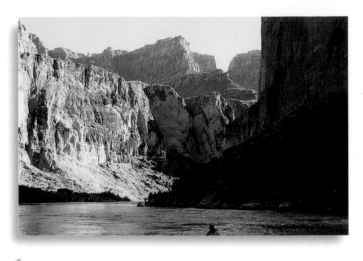

1 SQUINTING TO SEE
Here's a photograph of the scene I chose to paint on site. If you squint at it, you can see how the changes in value and color naturally divide the subject into a few big shapes.

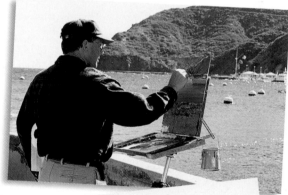

"To find these shapes, I squint frequently while viewing the subject and try to pick up on any kind of contrast that might separate one mass from another."

2 MAPPING OUT SHAPES
Using Burnt Sienna thinned with turpentine, I quickly indicated the main shapes in the subject, as well as a few of the smaller shapes.

3 BLOCKING IN COLOR
Next, I began to block in the fairly flat masses of color. My main concern at this point was to capture the relationship of one mass to another in terms of value and color. Although I did create some variations within each large shape, it was never enough to break up the shape. From a distance, each shape still reads as a whole, helping to maintain the structure of the painting.

4 ADDING MORE VARIETY
I continued massing while adding a little more variety to the shapes already included. Notice how I softened some edges to ease the transition between some of the large shapes.

5 ASSESSING THE WHOLE
Once I finished the block-in, I refined the value, color and level of detail within each shape, always checking to make sure all masses worked well together. On-the-spot paintings like **"Harding Rapids" (oil on canvas, 10 x 12" or 26 x 31cm)** when combined with a photo or two become invaluable references for work back in the studio.

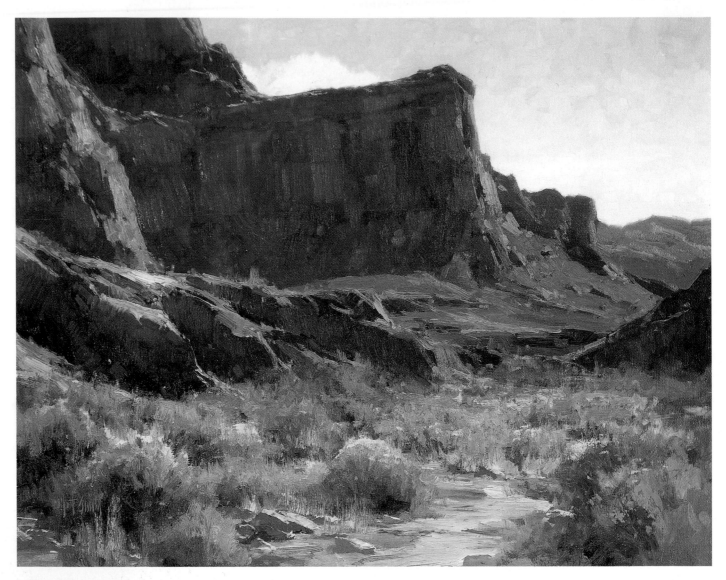

"SUPAI CLIFFS", OIL, 22 x 28" (56 x 71CM)
Within each of the four main masses in this painting, you can see how close I kept the color and value to maintain the solid shapes. I also included only hints of physical detail so as not to distract from the relationship of one mass to another. If I had looked into these masses too intently, my eye would have adjusted and allowed me to see endless information, tempting me to want to add it to the painting, thus fracturing the masses.

render the important elements, giving each a shadowed side and a lighted side, which makes them take on the corresponding three-dimensional forms (see sidebars on pages 17 and 23).

For example, a palo verde tree looks like a round circle, which then becomes a sphere. Similarly, a cliff might look rectangular and then become a cube. A pine tree might start as a triangle and then become a cone. All of this is accomplished through modeling, which means seeing them in their absolute basic

shape and then rendering them as form.

However, I never let my objects get generic. I continue to study my subject and define the drawing through positive and negative space to restore the specific character and silhouette of the individual objects. As an example, a palo verde, a pine and a cypress are all trees, yet each has a distinctly identifiable look. To paint them, I would cut into the base shapes in different ways to define the appropriate silhouettes.

As I complete the painting, I avoid

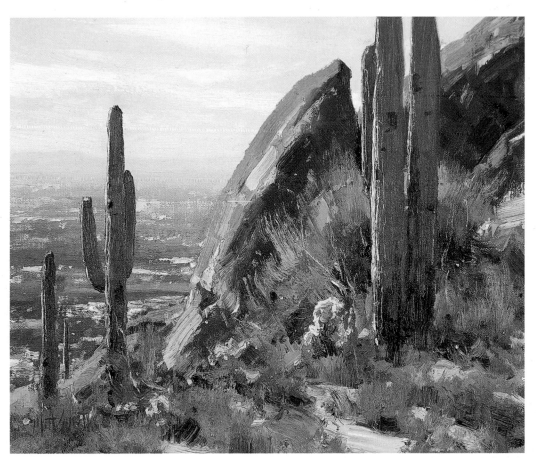

**"VIEW OF THE VALLEY",
OIL, 10 x 12" (26 x 31CM)**
The center of interest in this on-location painting is the two saguaros silhouetted against the large rock formation. Even though they are very close in color and value to the rock mass, they still maintain their own identity as a mass because of their unusual character. Separating one mass from another with character can be an interesting idea to play with, especially when dealing with subjects of human interest where the eye tends to focus.

**"TREELINE, GLACIER PARK",
OIL, 24 x 30" (61 x 76CM)**
Although the foreground mass is filled with the majority of information in this piece, it is the interest in the silhouette of the distant mountain that makes it the focal point. Even though this mass contains less detail than the foreground, the eye tends to move toward it because of its significant presence.

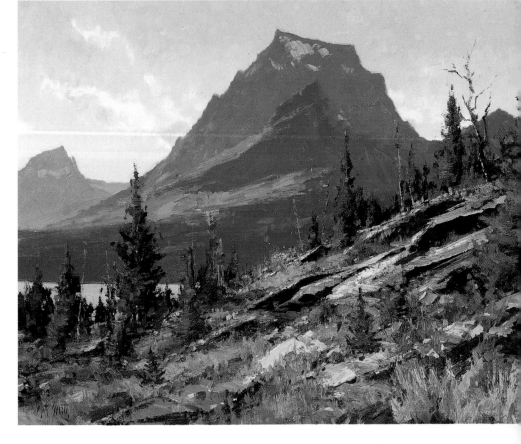

breaking up my big shapes with too much contrasting information. If there are too many dark and light contrasts within the individual masses, the three to five shapes will become ten shapes, ruining the simple structure of the painting. However, I've found that I can put as much detail and as many smaller shapes on top of the structure as I want, as long as I keep everything within each big shape in roughly the same value and color range. This allows them to read as large shapes from a distance.

"SEPTEMBER'S GOLD", OIL, 30 x 40" (76 x 102cm)
The focal point in this painting is the dominant aspen trunk just off center to the left. I grouped it with several other tree trunks to give it more importance. Even though this grouping isn't an outlined shape, it "feels" like a mass. I also included the greatest amount of detail and form modeling in this area. The remaining areas in the background are kept simple to convey a greater sense of depth, while giving further importance to the center of interest.

"HAYDEN VALLEY", OIL, 8 x 10" (20 x 26cm)
This small, on-location painting has four basic shapes — foreground, middle ground, background and sky. I massed the sage in the foreground to help lead the viewer's eye into the painting, like a trail. As you can see, I concentrated more on the overall shape of the sage as it grouped together rather than the individual bushes. This makes for a strong directional movement. I did the same with the distant pine-covered hills. At that distance, you see the entire shape rather than the parts.

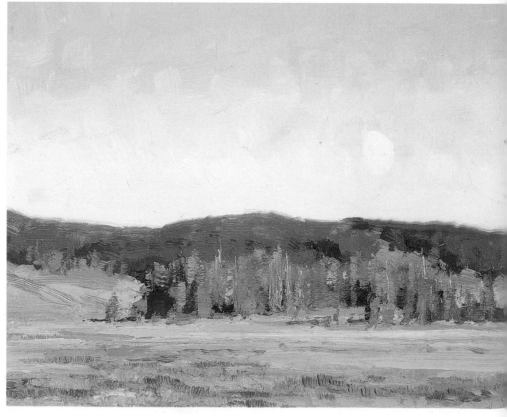

INITIAL DRAWING - PLACEMENT OF MAIN ELEMENTS.

ESTABLISH THE SHADOWS - DARKEST DARKS

AVERAGE COLOR WITHIN MASSES - 4 to 5 MAIN MASSES.

MODEL FORM - HIGHLIGHTS, MIDTONES, ACCENTS.

SOFTEN EDGES - DEFINE DRAWING

FINISH - SURFACE QUALITY

MODELING SHAPES

While a good design comes from the ability to see your subject as a series of big, flat shapes, the sense of three-dimensional depth comes from the ability to model those shapes back into volumetric forms. Follow through these six steps as I demonstrate how I start with simplified shapes, then put in the shadows, colors, core shadows and highlights to create form. In particular, look at how I cut into the forms with negative painting to keep them from getting too generic.

Enhancing your skills

I've painted for many years in the Sonoran Desert, where I've lived for most of my life. There can be a real lack of definitive form in its subjects. Due to the extreme heat, the plant life is very thin and wispy and often lacks obvious shape and form, similar to steam coming off soup or coffee. However, because of this, I've been forced to see and exaggerate the flat masses as well as the three-dimensional qualities of my subjects. Success at this comes through experience, which in turn comes from extensive study and practice.

I'm sure that if you continue to practice squinting, you'll learn to see shape rather than detail and form rather than line. You'll quickly learn to organize a scene into a powerful, attention-getting foundation, then be able to retain the painting's presence as you build up and restore the volume and depth in your subject. As I frequently tell students: While squinting, believe what you see and don't chase what you think you know. □

DESIGNED BY NATURE

Invite your viewers into your landscapes by following Gabor Svagrik's advice on utilizing and enhancing the big shapes in your subject.

"THE MAGIC OF THE DESERT", WATERCOLOR, 13 x 18" (33 x 46CM)
Rather than allowing this subject to fall into a series of dull, horizontal bands, I varied the edges of the shapes to include more dramatic diagonals. I then positioned the clumps of desert foliage in the foreground to subtly suggest a few more angles.

Once when I was driving through Idaho, I saw something that really put the concept of composition into perspective for me. I saw a whole bunch of hay bales, all nice and evenly stacked and lit by the morning sun. But there was one stack that had toppled over so that some bales were upright and others were facing all sorts of directions. To me, those that were toppled over were a lot more interesting than the rest. The diagonals mixed in with the horizontals and vertical lines gave my eye an exciting buffet of shapes!

Although this scene happened purely by accident, it reminded me how important shapes are to a composition. The situation proved how an artist can edit any scene and make it more interesting by adding, subtracting and changing shapes and angles.

Understanding composition's purpose
Each time I go outside to paint, I can easily get caught up in the many choices of subjects. I find so many appealing things — light, color, atmosphere and more — that it's easy to get distracted and confused. But eventually, I want to choose a subject that gives me some sort of feeling or makes an emotional connection so that my painting has a soul to it. Then it becomes my responsibility to take that feeling one step further by putting it on canvas for my viewers to share.

What's the best way to attract and hold a viewer's attention long enough to communicate my feeling or emotion?

24

"BIGWOOD RIVER", OIL, 30 x 40" (76 x 102CM)
Shapes and lines don't have to be obvious to be effective. Notice, for example, how I slightly darkened the water on the lower left to subtly "extend" the diagonals of the cast shadows leading up to the trees.

"Horsher's Farm", watercolor, 13 x 18" (33 x 46cm)
The large, horizontal shape of this old farmhouse serves as the anchor and center of interest of this painting. Notice how all of my other shapes and edges lead right to it.

For me, the answer is good composition. I can have great brushwork, dramatic values and beautiful color, but if the composition is not pleasing and inviting, the piece won't be as strong. The great thing about landscape painting is that I have the freedom to change the composition of my actual subject in order to improve it. In a way, a painting is like a movie — it's okay for it to be a fictional story as long as it's interesting and entertaining.

Starting at the center of interest
I think the best to place to start building a strong composition is at the center of interest. I often see paintings where there is no clear center of interest. The painting is just screaming all over, but the artist is not saying anything. So I usually begin by deciding what part of my subject is most strongly communicating the key emotion and let that serve as the center of interest. Then I stick to it throughout the painting process.

My next step is to position that center of interest on my canvas. Aesthetically, it's best not to place the center of interest in the center because it tends to dull the composition. One good way to find a naturally pleasing location for the center of interest is to imagine a line drawn diagonally from one corner of my surface to the other. Then I imagine

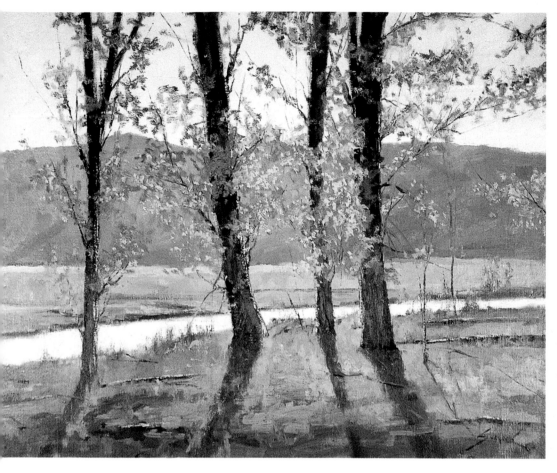

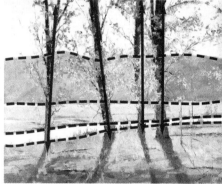

"SULA, MONTANA", OIL, 24 x 30" (61 x 76CM)
I was attracted to these beautifully backlit trees. Not only did they set a nice mood for the painting, but they served the composition well, too. The vertical trunks interrupt the dominance of horizontals typical of many landscapes.

another line coming from one of the remaining corners so that it hits the first diagonal line at a 90 degree angle (see sidebar page 31). Somewhere near the intersection of these two lines is a good place for the center of interest. Of course, this theory isn't written in stone, but it's worked for me so far.

In the later stages of the painting, I'll develop and accentuate the center of interest in several ways, perhaps through contrasts of color, color temperature, value and/or texture. But one of the main ways I draw attention to the center of interest is with the design of the shapes.

Designing with shapes

I believe the secret to a good design is having variety in the shapes and arranging them so they lead your eye into the center of interest. In landscape painting, there is a predominance of horizontal shapes, so I look for ways to work in vertical and diagonal shapes and lines. For example, I might take some artistic license and change the edge of a shape to be more diagonal. I also add shapes, such as individual trees, to provide great verticals, or I might insert a river, road or path to act as the classic diagonal tool for inviting a viewer's eye into a painting.

However, although I always try to have something leading the viewer in, I would never want to become formulaic in my designs. So I've worked at developing other ways to get the same effect that aren't quite so obvious. For example, I might suggest or imply a diagonal line with strokes of a different value or color, or I might add more texture in a diagonal path.

27

ART IN THE MAKING
COMPOSING WITH DIAGONALS

This is just the type of subject I love to paint. The low, early morning sun seemed to cast a quiet feeling of hope over the snowy landscape. I purposely chose a viewpoint that would accentuate this mood while incorporating the large diagonal shape of the creek for greater interest. However, in my original reference sketches and photos, the creek was centered, making the composition too symmetrical. To improve the design, I shifted the creek's shape to the left in my initial line drawing on the canvas. In a later stage, I also adjusted the angle of a tree to enhance the center of interest within the composition.

1 PLOTTING MY COMPOSITION
As usual, I began by tinting my canvas because it makes it easier to see and judge colors and values accurately. I used a neutral wash of cool Ultramarine Blue mixed with warm Cadmium Orange, which also serves to bring a nice harmony to the whole painting. Using this same mixture (not thinned with Liquin), I sketched in my composition fairly thoroughly to ensure the basic shapes were where I wanted them before painting.

2 WORKING UP THE BACKGROUND
Next, I laid in the dark values of the background trees, using a combination of Raw Sienna, Ultramarine Blue and Alizarin Crimson. Then I added the sky color, a mixture of Cobalt Blue, Titanium White and a hint of Alizarin Crimson.

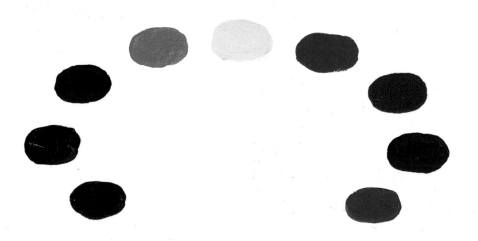

WHAT THE ARTIST USED

PALETTE
Titanium White (the brightest white)
Ultramarine Blue
Cobalt Blue
Raw Sienna
Yellow Ochre
Cadmium Lemon
Cadmium Orange
Winsor Red
Alizarin Crimson
Viridian

MEDIUM Liquin

BRUSHES A variety of soft and bristle brushes

SURFACE Canvas primed with rabbit skin glue and two coats of oil primer

3 MOVING TO THE FOREGROUND

For the snow, I used an off-white mixture of Titanium White plus Ultramarine Blue, Cadmium Orange, Cobalt Blue and a touch of Yellow Ochre. The only areas that I allowed to get closer to white are the planes directly lit by the sun. Then I added some of the larger trees to get some darks on the foreground. To complete the block-in, I painted the creek, making the top of the creek lighter and gradually getting darker to make it appear to move toward the viewer.

4 PERFECTING THE COMPOSITION

At this point, I decided the large tree on the left was leaning in too much. This was an eyesore to me, so I changed its angle. Then I laid in the cast shadows to anchor the trees. I drybrushed lighter colors onto the trunks and brought in some snow to give the trees more variety. I also modeled the background with touches of lighter values and some sky holes, but not so much detail as to draw attention away from the center of interest.

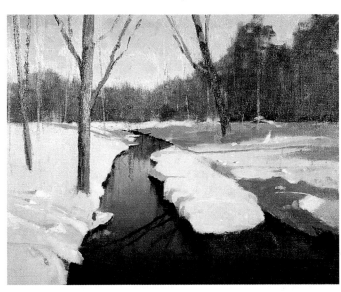

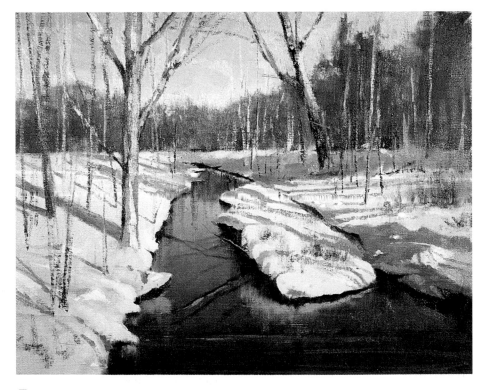

5 FINESSING THE MOOD

Finally, I suggested movement in the water by adding horizontal values and reflections. I also softened the edges between the forest and the snow, and added hints of pure colors, such as Winsor Red and Cobalt Blue, to spice up certain areas. Then I drybrushed some smaller trees, branches and shrubs for interest. To complete **"Mid Winter Afternoon"** (oil, 16 x 20" or 41 x 51cm), I added a few almost-white highlights to make the snow look bumpy and uneven.

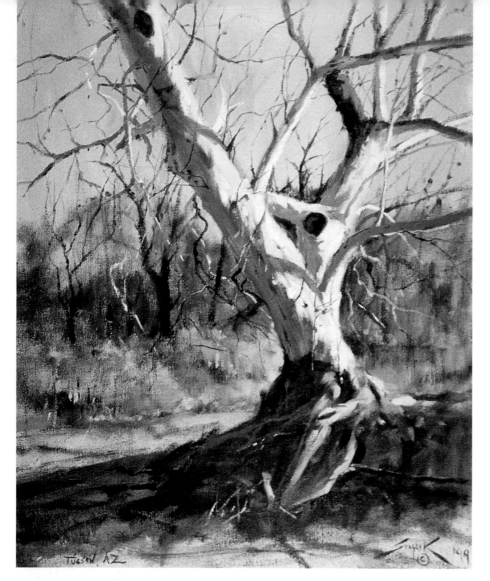

Tucson, AZ

"Lonely Sycamore",
oil, 20 x 16" (51 x 41cm)
The light falling on the white bark of the tree
was my inspiration for this painting, but the
shape of the tree made for a great composition.
The nearly vertical diagonals in its "Y"-shaped
trunk break up all of the horizontals in the setting.

"The Magic of Winter",
oil, 24 x 18" (61 x 46cm)
A big diagonal shape that moves in from
a corner, such as this river, is always an
effective tool for pulling a viewer's eye
into and up to the center of interest.

WHEN TO DO THUMBNAILS AND SKETCHES

Usually when I paint in watercolor, I do several small pencil
sketches. Not only do they help me resolve the composition
and tonal values, they give me more options for painting the
piece. If I'm not happy with the first sketch, I keep going until
I'm satisfied. With watercolor, you don't want to fuss around
on the paper and you can't change most of what you put
down, so preliminary sketches save a lot of time and energy.
When I paint large oil paintings, I usually do a small color
study rather than a pencil sketch.

I have noticed, though, that the longer and more often
I paint, the easier composing gets. Experience has taught me
to identify the problems and find solutions faster. With time,
good composition becomes second nature to all of us.

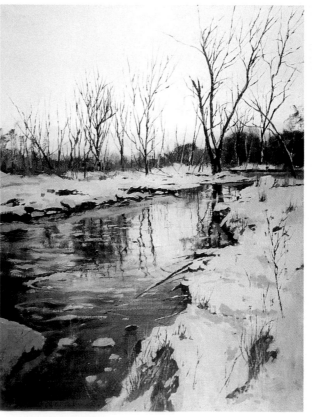

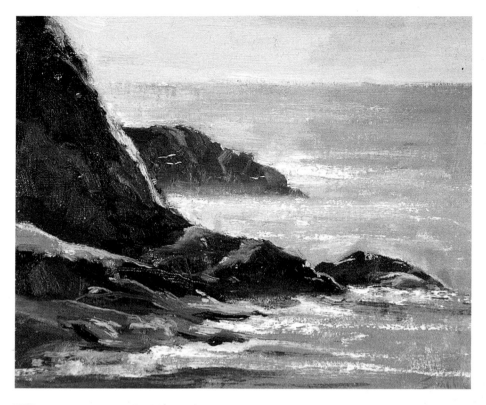

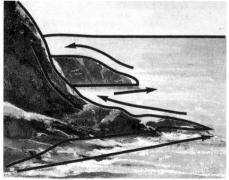

**"POINT LOBOS",
OIL, 10 x 12" (26 x 31CM)**
The success of this small plein-air piece rests on a good composition. The zigzagging shape of the coastal rocks draws you into and around the painting. There's also a dynamic relationship between the overall rock shape and the water/sky shape.

THE EASY WAY TO POSITION THE CENTER OF INTEREST

When I was in art school, I learned a quick and easy way to find a good location for the center of interest. I begin by imagining a line drawn diagonally from one corner of my surface to the other. Then I imagine a second line coming from one of the remaining corners so that it hits the first diagonal line at a 90 degree angle. I usually try to position my center of interest approximately near the intersection of these two lines. As you can see from these diagrams, it works for both horizontal and vertical formats with the first diagonal going in either direction.

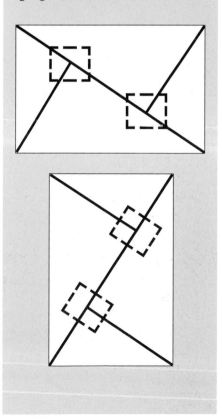

Variety in the sizes of shapes is also important. To solve this problem, I might simplify and merge two shapes into one. I also pay close attention to the intervals between shapes — for example, the spacing among a row of trees — so the negative shapes are also varied. In other words, I avoid creating compositions that are perfectly symmetrical and even. All of these additions and adjustments are done with an eye toward supporting the center of interest.

Taking control of composition
A perfect composition — one that will engage and entertain a viewer — is almost never found already existing in nature. No matter what subject I choose, I know I'll probably have to edit out some things and add others to make the painting work. And there's no reason not to change things for the sake of achieving a pleasing result. After all, no one will ever go back to the spot where I painted and hold up my painting for comparison. So if I have to move a tree or alter the shape of a bush, I do it without guilt.

As artists, we must remember we are not copiers, we are painters. We have the power to compose scenes in ways that will best express our emotional responses to our subjects and invite our viewers to share the experience. □

DEAN MITCHELL

ENTERTAINING THE EYE WHILE FEEDING THE SOUL

Let Dean Mitchell guide you to a better understanding of how our eyes react to tonal value. It will help you attract and keep your viewers' attention and communicate mood and feeling in your work.

"OZARK RIVERWAYS", WATERCOLOR, 20 x 30" (51 x 76CM)
The tones of the trees are actually quite similar, but because of the differing size relationships, it feels like the values are much farther apart. The combination ties the painting together, giving it a certain harmony because of the close values while providing depth from the changes in sizes.

No matter what the subject, I believe a good painting should have movement and variety to make it interesting. After all, the artist's job is to entertain the eye while feeding the soul. For me, that means choosing a subject that's often fairly simple and getting down to the essence of it.

That can be difficult to do, but the secret usually lies in developing a dynamic composition rooted in a strong tonal value pattern. In other words, I don't follow the values existing in the subject, but rather manipulate the lights and darks in a way that supports the message I'm trying to get across. By controlling my tonal values, I can draw viewers' eyes into and around a composition, clarify the most significant areas and set a mood for them to enjoy.

Moving the eye with value

In general, I don't have a lot of formulas or rules that I abide by, and that applies to values as well. For example, I don't think in terms of a regimented value scale with a certain number of steps in the range. But I do understand very well how value affects how we see, and I use that knowledge to my advantage.

One of my primary goals in any painting is to guide the viewer through the composition. When I'm designing a new painting, I never want to trap your eye in some corner or, worse, to direct your eye right out of it. That means

(continued on page 38)

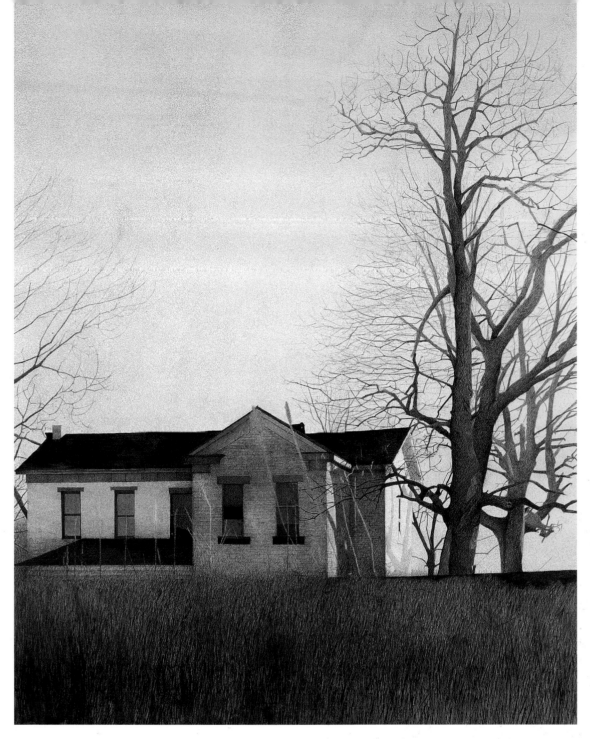

"PORTSMOUTH LEGACY",
WATERCOLOR, 29¾ x 21¾" (75 x 55cm)
Between the point of view looking up the hill and those strong tree trunks on the right, your eye could easily be pushed right to the top of this painting. You'd be left floating there with no way to re-enter the image. That's why I positioned a strong contrast of bright white against almost-black at the side of the house to provide an anchor. Notice how small that white shape is, yet how effectively it's working.

33

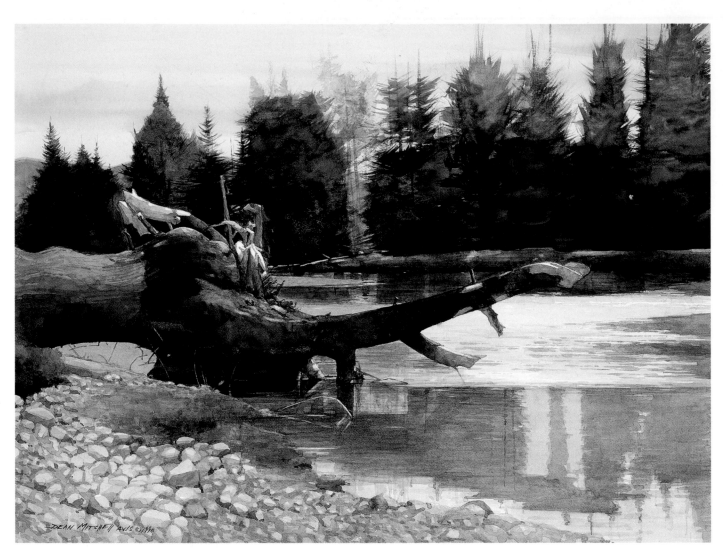

"Bathed in Sunlight, Yellowstone Park",
watercolor, 15 x 20" (38 x 51cm)
I never want to trap a viewer's eyes where they have no place to go. Instead, I want to move them around a painting. Here, I used an interesting balance of light and dark shapes to accomplish that. There's an intricate balance between the dark pine trees on the right and the heavy, dark tree base on the left, with plenty of patches of light to move your eye in and out.

TONAL PAINTER OR COLORIST?

Two phrases that occasionally pop up when talking about artists are "tonal painter" and "colorist". What do they mean? To me, a tonal painter relies on the pattern of light and dark for structure in a painting, often using minimal color with a lot of neutrals. A colorist, on the other hand, organizes space with color and typically uses a brighter palette.

Do you have to be one or the other? I don't think so. I'm probably a combination of the two — sometimes I'm quite tonal and sometimes I'm quite colorful. My feeling is, why lock yourself in to rules or formulas when you can keep trying new things? An open-minded approach will keep your work fresh, varied and interesting for both yourself and your viewers.

"BLUE WATER", WATERCOLOR, 15 x 10" (38 x 26CM)
Quiet paintings still need to have something going on to make them work. In this case, I used a simple structure of dark values in diagonal directions to lead your eye around the painting and create movement.

"HOLLOW", WATERCOLOR, 10 x 15" (26 x 38CM)
Art is a lot like music — you don't want to hear the same beat all the time. Instead, you want to hear a variety of sounds and tones working around the rhythm. That's how I composed this painting. Like a symphony, it has a lot of harmonious, subtle passages, but there are just enough light, staccato notes alternating with a few big, booming dark accents to keep it interesting.

WORKING WITH TONAL VALUE

This painting is a great example of how I often use dark tonal values to provide a dynamic structure for my work, resulting in a composition that is full of movement. The dark values create a path for the viewers' eyes to follow.

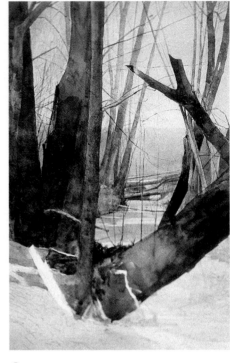

1 STARTING WITH THE LIGHTS
Over a fairly detailed pencil sketch on watercolor board, I covered the entire sheet with light values. Many of these areas will remain unchanged throughout the painting process. I mixed the subtle range of pale grays from complementary colors. Notice how I also kept many edges very soft at this point.

2 ESTABLISHING THE VALUE RANGE
Still using complementary mixtures but now in much darker tones, I began to establish a series of dark-valued shapes. I dropped in some Ultramarine Blue and Yellow Ochre here and there to put some variety in the color while staying in the same value range.

3 PUTTING IN MID-TONES
I continued building up the dark values throughout the painting with more rich, colorful grays. With my extremes of lights and darks fairly well established, I then began to put in some of the mid-tones.

WHAT THE ARTIST USED

SURFACE Watercolor board

BRUSHES Mostly sable flats and rounds

PALETTE
Yellow Ochre
Alizarin Crimson
Winsor Green
Hooker's Green
Winsor Blue
Prussian Blue
Cerulean Blue
Ultramarine Blue
Raw Sienna
Burnt Umber
Sepia

SUBSCRIBE & SAVE

Send no money. Mail today.

A year
for just $17⁹⁷

6 issues in all and savings of
50% off the newsstand rate!

WesternInteriors
AND DESIGN

GUARANTEED.
OR YOUR MONEY BACK. Every subscription
to *Western Interiors and Design* comes with a 100%
satisfaction guarantee: your money back
whenever you like on all unmailed issues!

Offer good in U.S. and
possesions. Please allow
4–6 weeks for mailing
of first issue.

NAME (please print)

ADDRESS

CITY/STATE/ZIP

EMAIL

Your e-mail address will be kept confidential and will not be made available to any third party.

or call **800.477.5988**

4JSS

4 MODIFYING TONES

At this point, adding the details such as the linear tree branches became my primary concern, although I continued to glaze over some areas to adjust values and enhance the composition wherever I thought it was necessary.

5 MAINTAINING THE OVERALL VALUES

Some warmer, brighter greens, yellows and blues, especially in the foreground and middle ground, brought the painting to life. In adding these colorful touches, however, I had to take care to maintain the flow and balance of the value structure. To give **"Ozark Riverways III" (watercolor, 15 x 10" or 38 x 26cm)** a final touch of texture, I mixed a bit of egg yolk in with the water and pigments and stippled and cross-hatched over some areas. The egg yolk gives the final texture glazes a rich sheen that matte watercolors cannot achieve alone.

I have to create visual paths that will repeatedly lead your eye around the painting, especially in and out of the focal area.

This is where tonal values become very useful. For most of us, our eyes are attracted to objects that are light or bright. So I often place shapes of light values in paths that visually "link up" and lead the eye vertically, horizontally and especially diagonally through a composition. However, shapes of dark values can be equally effective in directing your vision. Either way, I strategically place shapes of similar values to provide a structure for a painting.

Within the larger compositional value structure, I also want to lead the viewer to the focal area, the most important part of the subject. This is why it's even more important to understand that our eyes are instantly attracted to areas of extreme value contrast. Even in a large, dominant mass made up of one or very similar values, our eyes will be drawn to the smallest shape of an opposing value within it. Think of a speck of red wine spilled on a white tablecloth — you'll notice it for sure. So introducing a "foreign element" in the form of a value contrast can be a very effective tool in grabbing a viewer's attention and pulling it to a particular area. I use this phenomenon to emphasize that part of the subject I think is most important.

Setting a pace, setting a mood

Understanding that our eyes will follow visual paths of similar values and will be especially drawn to areas of high contrast seems simple enough, but the concept is actually a lot more complex. Tonal values also influence the pace and the mood of a painting, so I really have to keep the range of values in any given piece under control.

Typically, paintings that have a lot of contrast are very active. They will encourage you to move through the painting at a fast pace, and leave you with a feeling of excitement. Paintings possessing a smaller, more limited range

"FALLEN GRACE",
WATERCOLOR, 24 x 18" (61 x 46CM)
This painting uses many types of contrast to make it interesting, including value contrast. I carefully placed the big patch of snow in the foreground to lead your eye in, then let the little patches of snow dance around the tree. A light-valued patch toward the background carries your eye the rest of the way through the Image.

**"THIRSTY ROOTS", WATERCOLOR,
10 x 15" (26 x 38CM)**
This is a very unusual painting. The horizontal shapes bounce abruptly back and forth from light to dark with very few transitions in between. How did I keep the design from getting too broken up with value contrast? I used the diagonal shapes of the trees, along with subtle variations within these broad shapes, to lock the composition together and make it work as a unit.

"SUMMER HOME", WATERCOLOR, 7½ x 10" (19 x 26CM)
If you look closely, you'll see lots of variety in the edges and brushstrokes among the trees. But the muted values keep these areas quiet and make the house pop. That's supported by the extreme contrast of the white building and the very dark windows, which draws attention to the background and creates depth.

NOT JUST ANOTHER LANDSCAPE

One reason my work has a unique, distinctive look is that I deliberately pick offbeat subjects. I always try to find scenes that don't fit the idealized definition of landscape painting but still possess a certain sense of beauty. You can train your eye to look for the hidden beauty in nature, too, thereby finding great subjects that stand out and reflect your individuality.

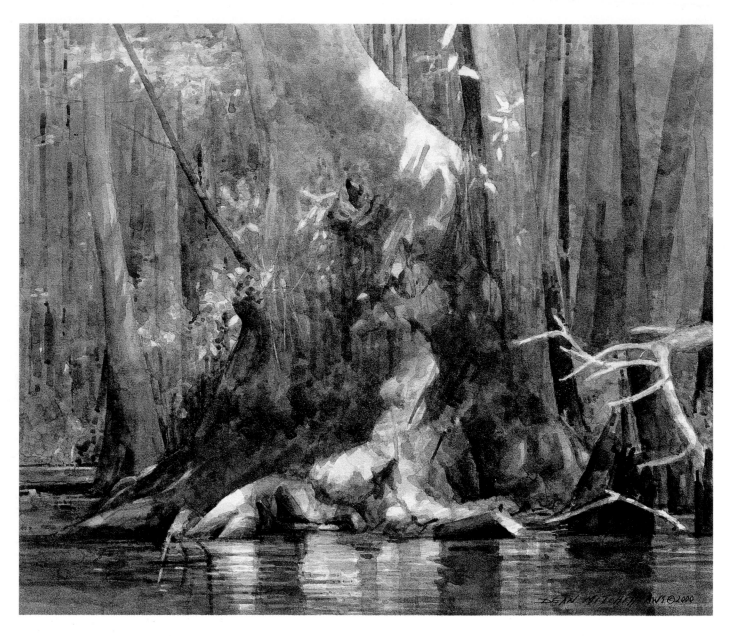

"Panhandle Cypress",
watercolor, 8 x 9½" (20 x 22cm)
I've found that I can often influence how a viewer looks at a painting by choosing a certain range of values. Images that are close in value usually offer a sense of mystery and invite you to slowly enter into them. Wanting to suggest a slower pace for this subject, I used a minimal range of values.

of values, on the other hand, tend to be more mysterious, inviting you to slowly enter and explore them. Knowing this, I deliberately choose an overall range of values that's most appropriate to the subject, pace and mood I'm trying to communicate.

Going beyond reality

As a fairly realistic painter, I am somewhat limited in how far I can exaggerate or manipulate my values. In a landscape, for instance, I still want to

suggest spatial depth so I have to make the broader, larger, heavier objects in front typically darker in value while allowing things in the distance to be lighter. Nevertheless, I always work around these minor limitations and come up with a structure of tonal values that allows me to guide the viewer around a painting at the perfect pace while expressing a particular mood. There are many exciting options, so I thoroughly enjoy the challenge of coming up with novel design solutions in terms of my tonal values. □

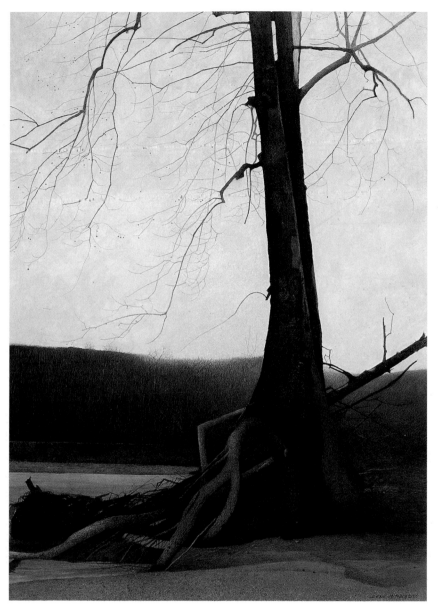

HOW TONAL VALUES WORK

You might want to consider approaching tonal values based on how the human eye sees. By understanding how we look at values, you can better manipulate the lights and darks in your paintings to suit your purposes. Some key points to remember are:

- Try to create visual paths that will repeatedly lead your viewer's eye around the painting instead of trapping it in some corner or pulling it right out of the composition. By paths, I mean shapes of light or dark values that visually "link up" vertically, horizontally or diagonally through a composition.

- Lead the viewer to the focal area with extreme value contrast. Introducing a "foreign element" in the form of a contrasting value can effectively grab a viewer's attention and guide it to a particular area.

- Choose a range of values that suits the mood you're after. Paintings that have a lot of contrast are typically very active and generate a feeling of excitement. Paintings possessing a smaller, more limited range of values, on the other hand, tend to be more mysterious and inviting.

- Don't feel you're limited to reproducing the values exactly as they're found in your subject. Be reasonable in exaggerating or manipulating your values so that you retain a sense of realism, but also challenge yourself to find a more interesting solution that makes the most of how we see tonal values.

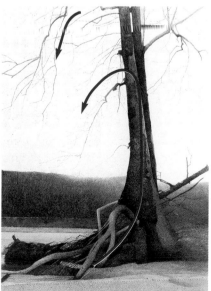

"STANDING TALL",
EGG TORE/WATERCOLOR,
30 x 20" (76 x 51cm)
Here, I used value to slow down the powerful movement of that dominant tree and maintain the peaceful, tranquil mood. If I had allowed the value of the tree to be much darker than the rest of the painting, it would have looked too "cut out". The thing that makes it work is the high contrast at the tree top and the minimized contrast at the base.

NIKOLO BALKANSKI

HARMONIZING THE COLORS OF NATURE

Painting is all about expressing the artist's vision, mood and emotion, says Nikolo Balkanski. Discover how you can use the powerful tool of harmonious color to bring that expression to life.

Everything in nature stimulates my imagination. For me, art is not about recording nature accurately, creating a technically perfect painting, telling a story or even bringing out a pleasant association in the viewer's mind. Art is about expressing my vision and emotion, about interpreting nature in a way that allows me to make a statement. This is why good technique and strong craftsmanship are only part of the picture.

I believe a truly good painting has two important qualities: an interesting concept and a fine expression of that idea. Almost anything can become a concept or idea for a painting, but it's usually the thing that catches my eye and attracts me to a scene, such as a ray of light, an intriguing shape or a combination of colors. As the artist, it's then up to me to find a way to communicate — to express — that concept to the viewer. The expression is what takes an ordinary idea and makes it interesting.

Of course, I have many artistic tools available to help communicate or express my concepts, including design, value pattern and paint quality. But I think one of the most powerful tools I use for expressing my artistic vision is color, particularly color harmony.

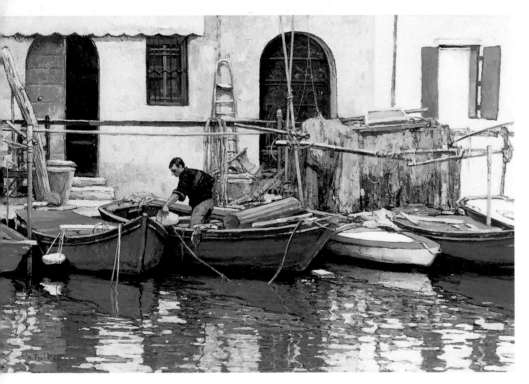

**"FISH MARKET (PESCHERIA AL MINUTO), CHIOGGIA, ITALY",
OIL, 20 x 30" (51 x 76CM)**
This painting is about contrast — the vertical expanse of wall against the horizontal band of boats against the vertical water. The bright tones of the boats also gave me a chance to work with more pure color than I usually do, but then they had to be harmonized with big expanses of neutral off-white on the wall. Notice how I put greens in the water, door and shutters to tie things together.

Learning the basics of color
There are actually two ways to think about and use color. Using color in a "decorative" way means filling the canvas with flat blocks of color to form a

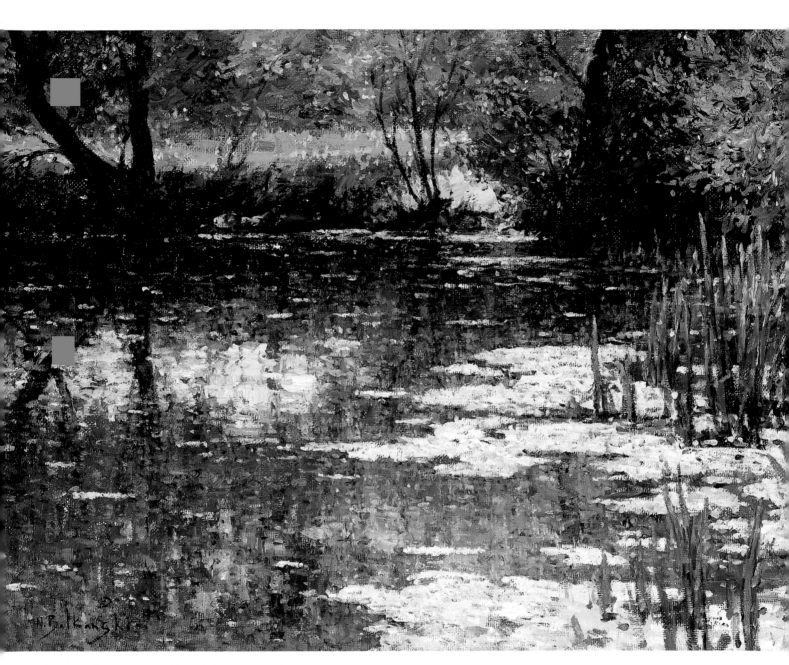

"SUMMER POND", OIL, 18 x 24" (46 x 61CM)
In terms of concept and design, I wanted to position the
horizon line very high to keep the focus on the exciting
horizontal and vertical textures in the pond's surface.
But that would have meant that nearly all of my colors were
warm. To balance them, I reflected the cool blue of the
sky in several places on the water. I also brought in cool
shadows to contrast against the warm light. For the
darkest areas along the far bank, I used mixtures of
French Ultramarine Blue and Alizarin Crimson because
I very rarely use black paint, which can deaden a painting.

"BIRCH TREES IN SUMMER", OIL, 12 x 24" (31 x 61CM)
This is a good example of a monochromatic color scheme effectively harmonizing a painting. It's a little tricky to do with green, so it requires a lot of variety. There's another purpose behind those passages of light yellow-greens and darker blue-greens, too. They create diagonals that break up the strong horizontals and verticals. I think the limited color scheme, the diagonals and the loose painting style all contribute to its relaxed, inviting feeling.

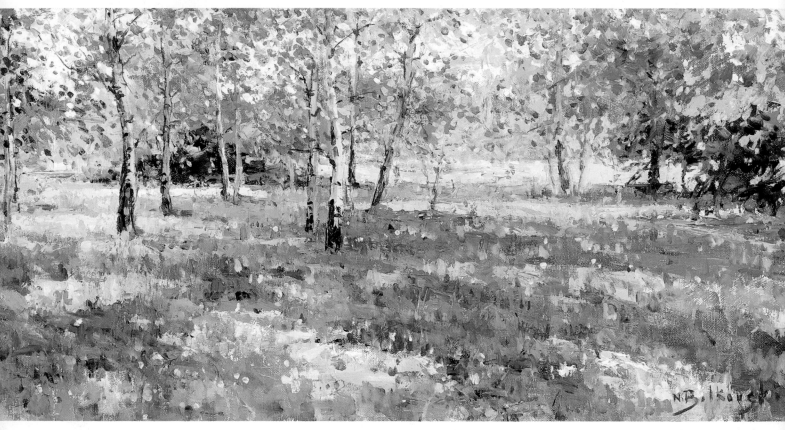

pattern. There's nothing wrong with this approach to color, but as a realist painter, I tend to use color in a "pictorial" way. This means seeing and varying the actual colors of nature to create three-dimensional depth and to provide the illusion of weight, form and structure in my objects.

Before I could use color in a pictorial or structural way, I had to understand how color works. First of all, every color has four properties: hue — the identifying name of the color such as red, yellow, blue; value — the relative lightness or darkness of the color; intensity — the quality of light which makes it brighter or duller; and temperature — whether it leans toward cool (blue) or warm (red or yellow).

Once I understood these four individual characteristics within each color, I was better able to determine different ways to choose and adjust my colors so that I could suggest depth and create harmony in my paintings.

Mastering the pictorial approach
Besides knowing how color itself works, I also had to study and learn how our eyes see color in nature. At its most basic level, light shows us the actual color of the object, along with a highlight and a shadow color so that the object appears to have a three-dimensional form. But over the years, I've also observed several general concepts about color in the landscape that are usually true, although different weather conditions can make light and

color act in unusual ways at times.

Generally speaking, though, colors become cooler (bluer) and lighter in value as they recede from the viewer, except for white which becomes slightly warmer and darker. So if I'm painting a flat plane, like a meadow, and I want it to recede into the distance, I have to gradually make the color of the plane somewhat cooler and lighter as it moves back so that it will appear to "lie down". If I paint it as a flat, even tone, it will visually stand up like a wall.

I've also noticed that the colors closest to the ground are usually warmer than objects that have some distance from the earth. So, for instance, shallow water that's very close to the earth is

(continued on page 48)

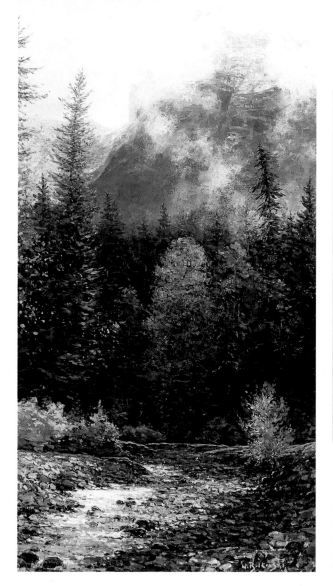

EVERY COLOR HAS TWO FACES

The human eye is more sensitive to color than to line or value. So it's important for artists to pay attention to colors and their symbolic meanings. Every color has a positive and negative feeling — for example, red can be courage or danger, black can be death or strength, green is hope and life but also jealousy, blue can be truth and wisdom but also sadness and depression, and purple can represent royalty and also grief. The advanced painter will make use of both sides of a color's symbolism, so that any painting is neither all positive nor all negative. Having both qualities in a work of art is more realistic, more true to life.

"GLACIER HEIGHTS, MONTANA", OIL, 48 x 24" (122 x 61CM)
When I saw the cool gray fog drifting across that mountain in the background and the bright sunlight sparkling across the stream in the foreground, I just had to paint this scene. The contrasts in the weather and light provided a dramatic concept for a painting, but the colors were all rather dull. That's why I put in that golden tree — it added to the drama in the painting.

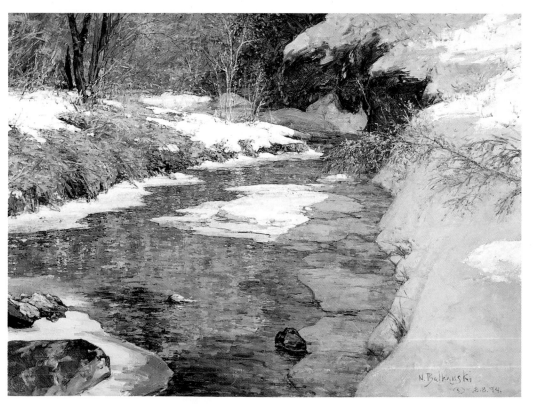

**"PROMISE OF SPRING",
OIL, 36 x 48" (92 x 122CM)**
The beautiful shape of the shadow cast by the snow-covered bank provided the concept for this painting. But a fairly monochromatic subject like this one would have easily become boring if I hadn't done something to keep it interesting. Here, I used thin paint in the shadow and thicker paint in the light, snow-covered areas to add to the feeling of dimension and enhance the concept in the painting.

45

ART IN THE MAKING
HARMONIZING THE COLORS OF NATURE

At some other time of year, this scene might not have been so special. But on this autumn day, I was very attracted to the changing colors of the grass and flowers across these rolling hills. Combined with the dramatic sky, the variety of colors drew my attention and became the concept for this painting.

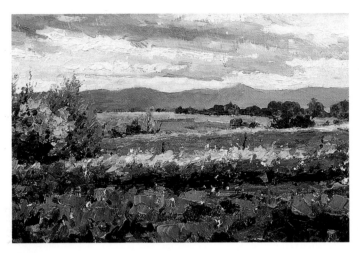

1 RECORDING MY IMPRESSIONS
Sometimes I work from photographs, but I much prefer to work from a color study done on location. This sketch was 7 x 11" (18 x 28cm), just large enough for me to record the main shapes, values and color notes of the subject. I worked quickly, using small and medium brushes and a palette knife.

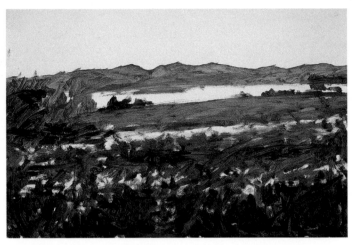

2 COMPOSING THE SUBJECT
Back in the studio, I used a big brush and thinned Raw Umber and Cobalt Violet to block in the darks of my composition on a large canvas, leaving the light areas free of paint. At this point, I was just positioning the shapes.

WHAT THE ARTIST USED

BRUSHES Firm bristle and soft squirrel hair brushes, both flats and rounds in a variety of sizes

Palette knife

SURFACE Double-primed linen

PALETTE

Titanium White	Cadmium Orange	Raw Umber
Lemon Yellow	Scarlet	Burnt Umber
Naples Yellow	Cadmium Red	Cobalt Violet
Cadmium Yellow	Permanent Rose	Dioxazine Purple
Buff Titanium	Alizarin Crimson	French Ultramarine Blue
Flesh Tint	Indian Red	Cerulean Blue
Yellow Ochre	Burnt Sienna	Permanent Green

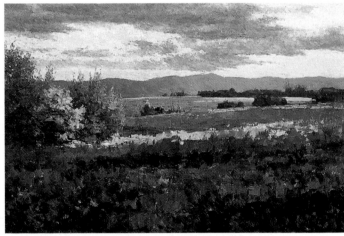

5 MIXING PURE COLORS WITH A KNIFE
Using nothing but a palette knife to capture the chaotic movement of the grasses and flowers, I finished massing in the color in the foreground. I used a lot of pure, warm colors right from the palette and let the knife do the mixing on the canvas.

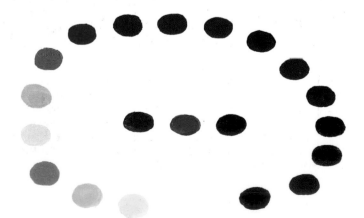

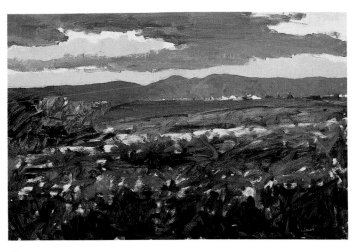

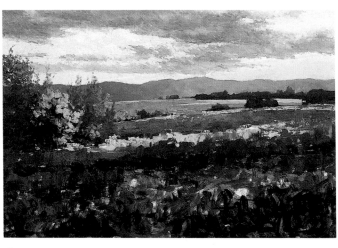

3 CREATING A BACKDROP
Once that was partially dry, I began massing in the approximate colors, generally focusing on getting the shapes and values right in the background. Already there was a harmony of cool greens, gray-blues and lavender-grays. I like to work from the background to the foreground because the background usually creates the setting for the more important areas to come.

4 TRANSITIONING TO WARMS
Moving into the middle ground, I continued massing in the colors with brushes and a palette knife. This area was so simple in its composition that I was free to play with the values and colors here. I allowed these greens and browns to be a little warmer, but they're still fairly cool.

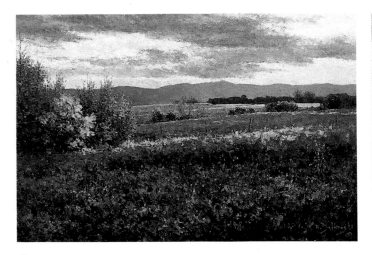

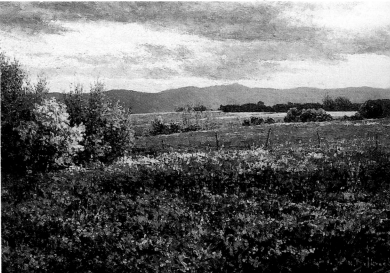

6 "GROWING" THE SUBJECT ON THE CANVAS
Switching back to a brush, I then began to add more dots and strokes of color to bring out and define some of the forms and shapes. My colors fell into an unrelated color scheme of primarily reds, red-orange and reddish-brown along with blues, blue-greens and greens. But notice that I didn't put in too much detail. To me, my approach to building up the painting was the same as the way the grass and flowers grew up in nature — I started with the ground, built up the grasses and then put in the flowers across the top.

7 FINE-TUNING THE HARMONY
Once I'd finished that stage, I set the painting aside for a while. After studying it more, I felt that the central white shape was too straight and too strong, so I broke it up by softening it on the right and adding more touches of lights in the foreground. I also lightened the clouds to create more of a harmony among the colors, and changed the shape of the trees on the left to make them less symmetrical. With this, **"Autumn at Addenbrooke Park" (oil, 24 x 36" or 61 x 92cm)** was complete.

47

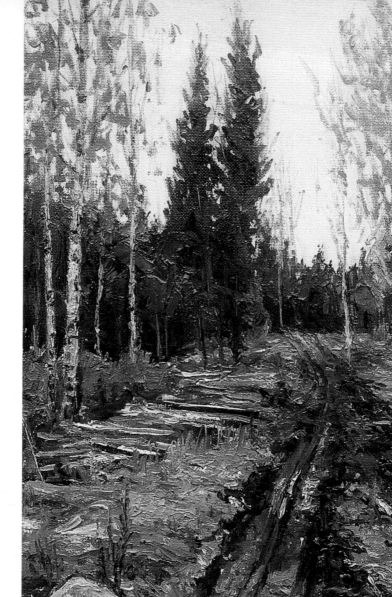

**"LOGGING ROAD, FINLAND",
OIL, 16 x 11" (41 x 28CM)**
I don't always paint exactly what I see.
In fact, I often change some part of the
subject to enhance the concept of the
painting. Here, I wanted to accentuate the
shapes of the trees, so I painted the sky
as a pale yellow wash instead of any blue
sky color. The light tone also balances the
darkness and weight of the trees and road
and harmonizes with the greens and
yellow-greens throughout.

usually a warmer blue than deep water.

Another thing that's a little harder to
see in the landscape is reflected color.
Reflected color is easily observed in still
lifes and figures, but it happens in a
landscape, too, because everything in
nature is connected. So as a light mass
approaches a dark mass, it begins to take
on some of the reflected darker color and
gets a little darker; as a dark mass
approaches a lighter mass, it starts to
absorb some of the reflected light and
gets slightly lighter. Here's another
example of this phenomenon at work: If
a tree branch is next to a patch of blue
sky, some of the blue will seep into the
edge of the branch and some of the

branch color will seep into the sky.

Then, of course, there are the
seasonal changes in colors. Greens, for
instance, generally tend to be much
cooler in the spring but look much
warmer in late summer. Fresh snow is
bright and cool, but snow that's been on
the ground for a time is a little dirtier
(yellow-brown) and often a little warmer.
Some seasons, particularly summer, don't
offer much in the way of color variety,
which is why I often paint at unusual
times of day, such as early morning or
late afternoon. The varying strength and
direction of the sun at different hours
will vary the colors and make a subject
more interesting.

Making the most of color
Once these concepts are mastered, all
artists can go on to use color in the most
sophisticated way to bring not only
pictorial realism but also greater
expression to their paintings. Using color
at this level means finessing and
harmonizing the overall color scheme —
sometimes completely overriding what's
there in the subject — in an emotional
way that communicates the artist's vision.

Learning to harmonize color cannot
happen by following recipes or
memorizing rules. It has to be "felt" in
the same way a good cook intuitively
knows what spices to put in the pot.
However, by looking at my own work

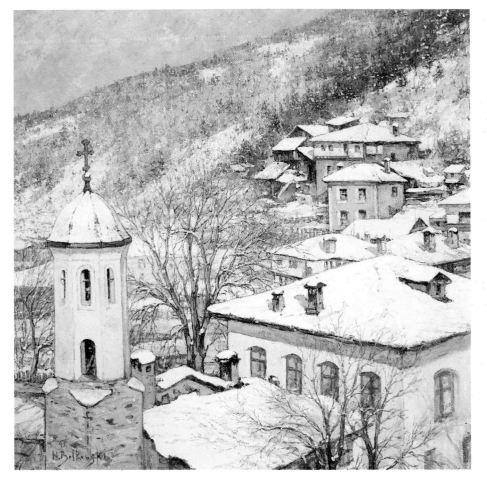

TAKING LIBERTIES WITH LIGHT

If the actual light source on your subject is not where you want it, put it where you need it. Often, changing or adding light will improve the balance and flow of the painting and make it more effective. So don't feel like you have to follow the light source exactly — it's okay to adjust it.

"VIEW FROM SHIROKA LUKA, BULGARIA", OIL, 30 x 30" (76 x 76CM)
The name of this town translates to "Broad Valley". I particularly liked this view because it had a good composition from the buildings snaking across the scene in a big "S". To emphasize that direction, I used a monochromatic palette and put the brightest variations of pale yellow and pale yellow-green in an S-shaped path. Even one more color would have been irritating and would have thrown off the whole effect of the high-key, light-valued color scheme.

and those of other artists, I've found a few consistent sources of color harmony to consider:

- **Related colors.** Also known as analogous colors, two or three colors that sit next to each other on the color wheel — such as orange, red and purple — often look good together.
- **Unrelated colors.** On the color wheel, any two colors that sit directly across from each other (such as red and green) or even roughly across from each other (such as red, yellow-green and blue-green) will complement and balance each other in an exciting way. True opposites will, of course, create the most vibrant effects.

- **Colors with white or black.** A whole range of colors will often harmonize with one another when they're all mixed with white or with black. Even placing shapes of white (such as patches of snow) or black will help harmonize colors.
- **A common color.** Color harmony can also result when all of the colors used contain a common color, such as red or yellow.
- **Monochromatic color.** This approach means using a varied range of values or intensities of the same color. These concepts are just guidelines, however. After many years of painting, they have become natural and familiar to

me and I no longer have to think about color harmony in such a precise way.

Expressing vision
As artists, we have the privilege of varying from nature and using color in the ways we think best. But what guidelines do we follow in deciding when and how to alter color? For me, it's fairly simple. On a basic level, I use color in a pictorial way to create depth and structure in my painting. Then I add to that the idea I wish to express, and let that guide me in choosing some type of color harmony that will support my vision. In this way, I can paint landscapes that look realistic but are still a unique expression of me. □

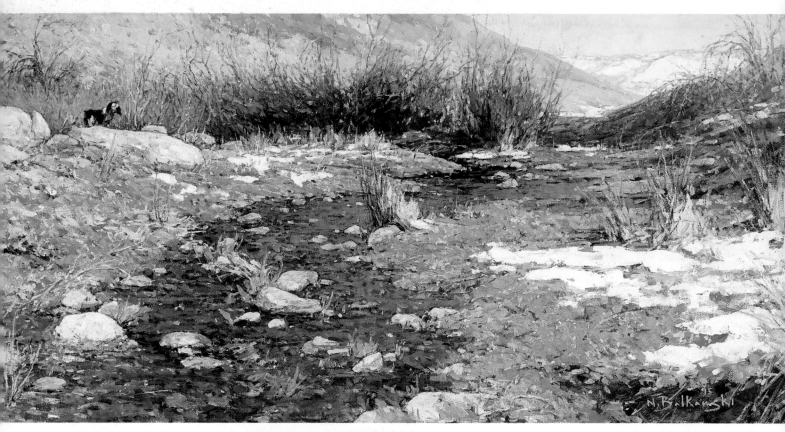

"WHITE RANCH PARK, GOLDEN, COLORADO", OIL, 15 x 30" (38 x 76CM)
Green has to be handled carefully because it changes so much with the seasons. I painted this on an early spring day, so I had to keep that new grass at a very cool temperature. The green grass and blue water were also quite rich in color, so I harmonized their intensity with the neutral colors of the snow and rocks.

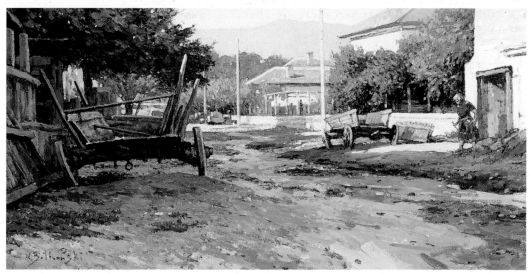

"VILLAGE SHADES, BULGARIA", OIL, 12 x 24" (31 x 61CM)
My friend lives on this street in Bulgaria, and I always love to paint it when I visit him. On this particular day, there was a lot happening in the street, plus it was summertime at the middle of the day when the colors are brighter and have more contrast. Fortunately, the shadowed areas were filled with neutral colors, which kept the bright whites and blues from overpowering the painting. The only addition I contributed to the subject was the figure in blue for an extra touch of bright color.

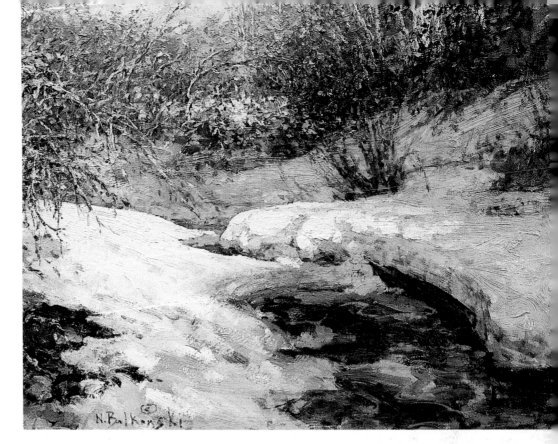

"Spring Day, Colorado", oil, 16 x 20" (41 x 51cm)
What attracted me to this subject was the way the light was breaking through and hitting those snow-covered, icy branches. The idea that spring was on the way gave the painting a nice feeling of optimism. I also liked the contrast between that one warm spot and the rest of the cools. Contrast is good for a painting — it's more natural than something that's entirely happy or totally depressing. To bring out that concept of contrast while still creating a harmonious color scheme, I used a lot of blues offset by complementary oranges.

5 TYPES OF COLOR HARMONY

Learning to harmonize color comes more from intuition than from recipes or rules. However, as you continue painting, you may want to consider focusing on one of these five types of color harmony:

1 Related colors — two or three colors that sit next to each other on the color wheel

2 Unrelated colors — any two colors that sit directly across from each other (such as red and green) or even roughly across from each other (such as red, yellow-green and blue-green)

3 Colors all mixed with white or with black

4 A common color mixed in with all other colors used

5 Monochromatic color — a varied range of values or intensities of the same color

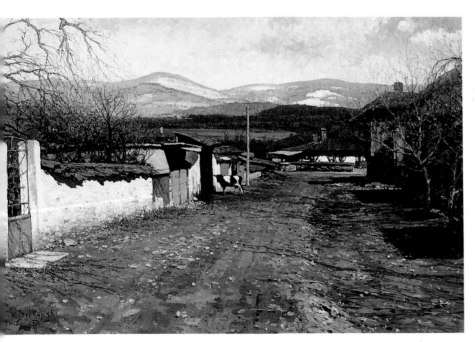

"Spring Day in the Country, Bulgaria", oil, 24 x 36" (61 x 92cm)
The sharp, long cast shadows show that I painted this rural village late in the afternoon. I like late-day light because it offers richer, warmer color with more reds and oranges. But to ease the transition between the warm browns and oranges in the foreground and the cooler tones in the background, I used shapes of white. The whites make this painting work because they link all of the individual parts.

MASTERING THE SUBTLE NUANCES OF COLOR TEMPERATURE

Creating natural, believable landscapes depends on your ability to work with color temperature. Timothy R Thies explains how to identify, compare and correct your colors' temperatures so you can capture the subtle beauty found in any type of light.

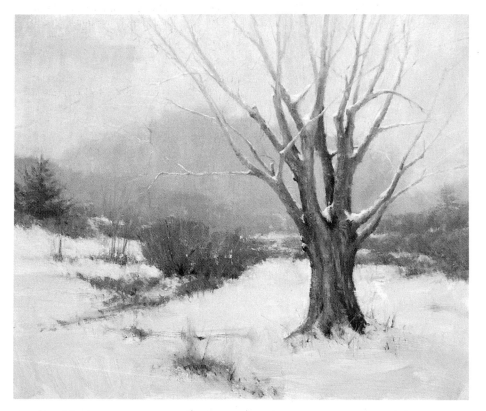

"WINTER MAPLE", OIL, 20 x 24" (51 x 61cm)
In this painting, the main theme is the maple tree. I was on location painting in Northern Vermont and used my sketch to execute this finished painting. However, I combined my sketch and a different slide for elements in the background. When I was finishing up this painting, I thought it needed something else so I added three snow geese and a few birds. I had to be careful not to take away from the sugar maple, so I painted all of the snow geese flying out of the snow storm in a close value range.

I have been on a journey to perfect my paintings for 21 years. During that time, I have found that one of the most interesting and sometimes challenging aspects of painting is color temperature.

When I started out, I was consumed with finding out the "simple" answers to painting the temperature of color and light so I asked every painter I knew. A well-known landscape artist in Colorado gave me one solution. "Its simple", he told me. "Cool light produces warm shadows and warm light produces cool shadows".

This statement is simple and true, but understanding it is a bit more complicated. It took time and patience for me to fully comprehend. What I know now is that seeing the temperature of color and light is all about discerning how warm or cool a color is compared to what is next to it. Comparison is the key to accurately painting the subtle nuances of temperature in colors as revealed by the temperature of the light. These subtleties allow me to capture the distinctive qualities of light, time of day, weather conditions and atmosphere of any scene.

Learning to mix colors

Like many artists, nature beckons to me on bright, sunny days when the sun bathes objects in a warm light while casting cool shadows over the land. For many years, I painted exclusively on sunny days simply because I convinced myself that overcast light conditions — with a cool light and warm shadows —

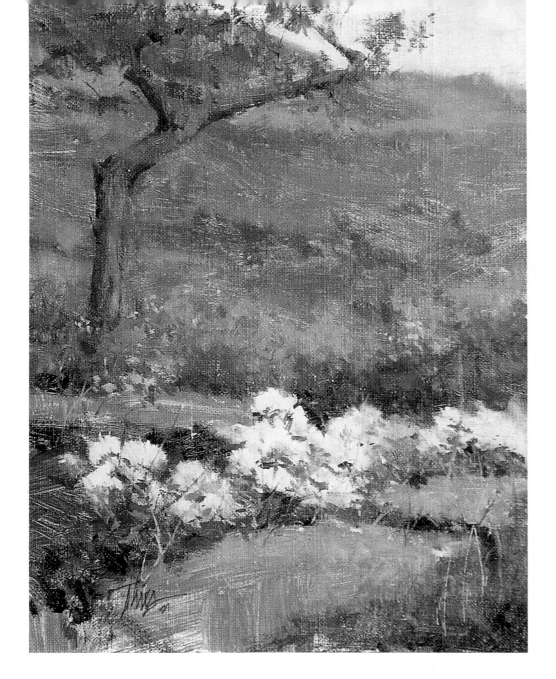

did not interest me. But the truth was that I really didn't understand painting in cool light. It wasn't until I built a north light studio that I began to notice the differences of painting in cool light.

In the studio, I began to experiment with painting the figure and found that in a traditional north light studio, the lightest lights are very cool. White is the coolest color on the palette so each time I added white to a color, the mixture became even cooler. Conversely, the shadow side of the figure was warm — the perfect place for transparent warm colors. I started making progress. However, I must admit that learning to paint in a cool light environment was

challenging, and many unsuccessful attempts left me feeling frustrated.

So I hit the books again and studied the work of the master artist and teacher Richard Schmid. After reading his book "Richard Schmid Paints the Landscape," I found that the exercise of painting color charts was one of the most important steps to solving my frustration. I have painted my charts three times now (see sidebar page 59) and each attempt has added to my understanding of how every color has a temperature and how these temperatures can be modified with the addition of other colors and/or white. Painting the charts gave me the confidence to head

outside to observe nature before I began a painting.

Applying my knowledge outside
Once outdoors I decided to look more closely than ever before, and then to look even closer still to really see the colors' temperatures. I started to notice the color of the light itself and the way it influences the subtle color gradations within light and shadow. This simple exercise enabled me to identify the most obvious, dominant one or two colors in any subject and, from there, to determine whether my painting should have an overall warm or cool tone. This then helps me establish the relationship

"A Castle in Wales",
oil on linen, 12 x 16" (31 x 41cm)
I had always wanted to see a real castle and this gave me an opportunity to paint it in overcast light. There was this eerie, mysterious sky behind the castle. I was so excited about it, I painted it very quickly. It was a good thing because the light changed and never returned. I painted the light areas of the castle with Cobalt Blue Light plus Terra Rosa and Viridian Green, a cool mixture that relates to the colors in the sky. The darker areas of the castle are mixtures of Transparent Oxide Red with Sap Green and Yellow Ochre, all very warm compared to the colors in the light.

between the lightest light and the darkest dark — and their temperatures — as compared to one another. All of this information assists me in interpreting these colors into strokes of paint.

Let's say, for example, that I'm painting a stand of white pines. On a sunny day under warm light, the light areas of the tree could be mixtures of predominantly warm colors, such as Sap Green plus Cadmium Yellow Deep with a touch of Cadmium Red or Terra Rosa and White. The cool, shadowed side of the tree could be the same Sap Green but cooled down and darkened with Ultramarine Blue or Alizarin Crimson. On an overcast day, however, the light areas of the pines might be a cool mixture of Viridian Green and Permanent Rose plus Cobalt Blue Light and White. The warm shadow could be mixtures of Sap Green plus Transparent Oxide Red with small amounts of Cadmium Red, Terra Rosa or even Alizarin Crimson.

Perhaps the most important thing I've

learned is to look closely and compare temperatures before putting down a single stroke of paint. I look at the color with my eyes wide open, mix what I see and then look again, even closer to compare and adjust my color before applying it to canvas.

Choosing to work in cool light

Now that I know how to see and mix the nuances in the temperature of light and color, I feel confident about painting under any type of light. I look forward to painting landscapes on cloudy days as much as I do on sunny days. It puts a lot more variety in my work and in my finished paintings. Plus, painting landscapes in overcast light lets me spend all day doing what I love to do because the light remains literally unchanged for extended periods of time. One more advantage is that the same subtle light conditions are prevalent on the palette, the painting surface and the landscape — painting with this quality of light is easier.

I feel very fortunate to live and paint in Vermont. Long winters and misty conditions lure me outside to experience the sound of nature's silence. Days like these allow me to become introspective. My thoughts meander and unfold like the painting process itself and I am reminded of the freedom I experienced as a boy. The only sounds I hear are my footsteps in the snow and perhaps the call of a distant bird. With pochade box and canvas in hand, my excitement grows as I approach the site of my next painting. In the quiet surrounding me, I notice that the colors of the landscape seem to merge and become unified by the subtleties of soft edges. Overcast light is very mysterious and slowly I sink into the rhythm of nature as my painting unfolds with each stroke of my brush.

It is my hope that I've given you some incentive to go out painting on an overcast day, see what you see and paint the subtleties of cool light. I wish you good painting. □

**"ROSES AFTER THE RAIN",
OIL ON LINEN, 14 x 18" (36 x 46CM)**
I really like the landscape after a good rain. All of the colors seem to be more vibrant. If it stays overcast for awhile, the cool lights seem to glisten and the warm darks are really dark and wet. My entire focus was on color temperature changes here of red, green and pink. The color temperature differences were plainly visible, so it was easy to push or exaggerate the coolness of all the colors in the light and warm up the colors in the shadows.

"BURNT COVE", OIL ON LINEN, 11 x 14" (28 x 36CM)
This was a brand new building on a pier in Maine. I had fun making the lobster shack look old and almost ready to fall into the ocean. The underside of the pier gave me the perfect opportunity to push the warm darks, almost black in the darkest darks. Here, I used mixtures of Transparent Oxide Red plus Sap Green, Cadmium Red and touches of Ultramarine Blue. The reflections of the shack in the water are very warm highlighted with cool, reflected light from the sky.

ART IN THE MAKING
FACING A TEMPERATURE CHALLENGE

While roaming around London, I went in search of an interesting market scene, preferably in the rain or in overcast light. Finding such a scene was no problem in London! This market was near Picadilly Circus. I walked back and forth and around the market, looking for interesting subjects to paint and shooting plenty of

reference slides. I especially enjoyed the challenge of working with the temperatures in this subject because of the incandescent light bulbs under the canopies. Nature gave me cool light and warm shadows, but mankind gave me an extra dimension of warm light and cool shadows in this one area.

WHAT THE ARTIST USED

OIL PALETTE

Transparent Oxide Red	Cadmium Lemon
Permanent Alizarin Crimson	Yellow Ochre
Terra Rosa	Sap Green
Permanent Rose	Viridian
Cadmium Red	Cobalt Blue Light
Cadmium Yellow Deep	Ultramarine Blue Deep
Cadmium Yellow	

Flat bristle brushes, Nos. 8-12

Flat sable brushes, Nos. 2-44

Palette knife for scraping paint down to the canvas and applying thicker paint to the surface

Stretched linen support

1 COMBINING IMAGES
I ended up choosing six different slides, several of which had only one primary figure in them. For the setting, I worked off one slide that included fruit and vegetable stands and lots of flowers for color. I then set about incorporating the figures from the rest of the slides into my final composition, scaling their heights up or down accordingly to fit their positions within the landscape. At this stage, I already had a clear mental picture of what I wanted the finished painting to look like.

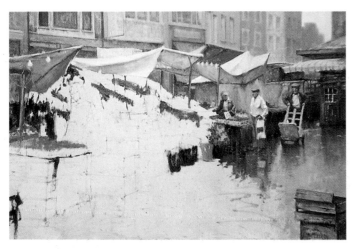

4 ADJUSTING TEMPERATURES
Next, I established some of the darks under the canopies and lightly indicated where the other two figures would go. I also continued to refine the buildings in the background, not only in the perspective lines of the drawing but also in the color temperatures. I used color mixtures that were lighter in value and cooler in temperature to make them recede. I then started thinking about how to approach painting the figures in the foreground. Should I paint the figure first and then the background behind it? What would be the next most logical area to paint?

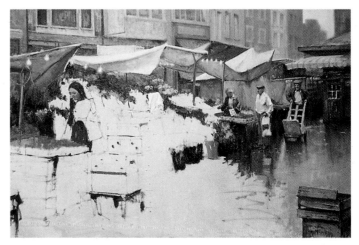

5 MOVING TO THE FOREGROUND
I decided to work from left to right, from under the closest canopy up to the young woman holding the flowers as well as the flowers behind her so I could compare the colors of those flowers to her flesh notes and clothing. This passage in the painting became an important transition, revealing the difference between the warm light and cool shadows created by the light bulbs under the canopies and the cool light and warm shadows of the flowers out under the natural, overcast light. I also began to paint the main point of interest — a woman standing in front of a cart of boxed vegetables, examining the lettuce.

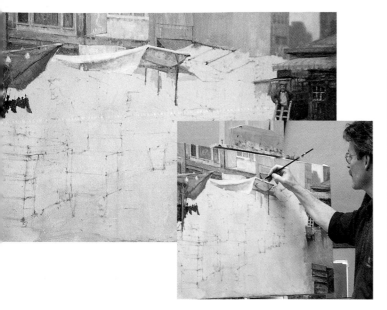

2 SETTING A COOL TONE

Working in the studio under cool north light and following my compositional sketch, I began by mixing Cobalt Blue Light and Yellow Ochre with White for a light cool tone and washing it over the entire canvas. Taking a paper towel and dragging it over the canvas gave the surface an interesting pattern. Next, I started plotting out my composition by drawing light lines with a mixture of Ultramarine Blue and Terra Rosa to indicate boxes and major shapes.

When I started painting, I wanted to put paint on accurately both in terms of value and color temperature. Here, the overall temperature of the light was cool with the shadow areas being warm. Since it's raining, the darks appear even warmer and darker. I thought the easiest place to start was in the background, including one figure.

3 FILLING IN THE PUZZLE PIECES

I approach painting like a puzzle, fitting in one piece of accurate color at a time. So before I put in each stroke of color in the other figures in the background, I compared it with the colors and temperatures of the figures and background objects. Is the color warmer or cooler? Is the color lighter or darker to the flesh notes of the men? By comparing each addition to the colors, values and temperatures I already knew to be right, I made sure my painting was correct from the very beginning.

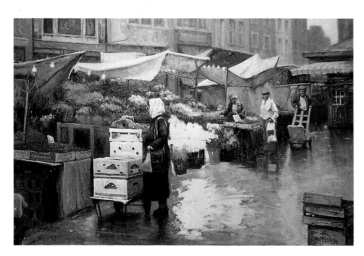

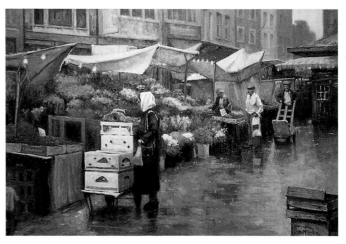

6 CLARIFYING THE FOCAL POINT

Realizing that the woman holding the flowers detracted from the woman purchasing the lettuce, I decided to paint her out. After all, with so many shapes and edges pointing at the "lettuce lady", she should be the clear center of interest. I then focused a lot of attention on her in terms of the drawing, the edges (both hard and soft), the boxes of vegetables she was standing over, the reflections under the cart and, of course, the color temperature changes. For instance, the shadows under the cart were very warm, but as they came towards the viewer, they got cooler and merged into the wet pavement.

7 FINISHING WITH ACCENTS

To finish "London Market" (oil on linen, 24 x 36" or 61 x 92cm), I put in my final accents of color, still watching the temperatures. I paid close attention to the subtleties of the colors where each color shape merged into another. Should each color be vibrant or subtle? My lightest light was a cool color on the white scarf of the "lettuce lady", and my darkest dark was a very warm dark, almost black, on her dress. Finally, I worked with the edges around my center of interest, putting the softest edge where the front of her dress merged with the shadow side of the boxes of vegetables and defining one of the hardest edges on the boxes.

"THE WYE VALLEY",
OIL, 16 x 24" (41 x 61CM)
Driving along the Wye Valley in England, we came around a corner and there it was. For an overcast day, there was a tremendous range of values. It seems like England and New England both can have very light lights and very rich dark darks. My main point of interest was the ancient oak trees in the foreground. Notice how warm the shadows are inside the tree and how cool the lighter areas of the tree are. I happen to be a fan of the patterns of the farmland in England, so this scene served as an interesting composition in pattern and value.

Working on location when it's overcast allows you to work at a larger size because the light stays consistent for an extended period of time. Here I am painting in 20ºF weather.

THE QUESTIONING APPROACH

Since the experience of painting is subjective, I will attempt to describe my approach to landscape painting. Here are a few key steps and questions I ask myself before starting. I offer them in friendship with the hope that a point or two learned along the way will help you discover the joys of painting nature's beauty in any light.

The first step is to search for a place or a scene that captures your attention. In my case, the scene actually jolts me into action.

Next, ask yourself, What is the main point of interest and what do I want to say or express in paint? If this is a bit challenging at first, ask yourself what attracts you to the subject — is it the drawing, the rich warm colors, soft edges, color temperature or perhaps the contrast of shadow and light?

Then look for the subtle differences of color changes. By this I mean stop, look and observe. Nature is always the best teacher.

Once you are set up on location and have selected your composition, move on to the next question — where is the darkest dark and the lightest light? Once these are identified, determine the softest and the hardest edge.

Next, select the easiest color to identify in the landscape and choose your painting process. Then ask yourself, Do I want some of the original wash to show through on the finished surface and where do I want to use thick paint?

Whatever painting process you choose, take the time to focus on the finished results right from the start. Visualizing your painting from the beginning is a great idea because it provides a roadmap to follow.

When these questions are answered, let your creativity flow.

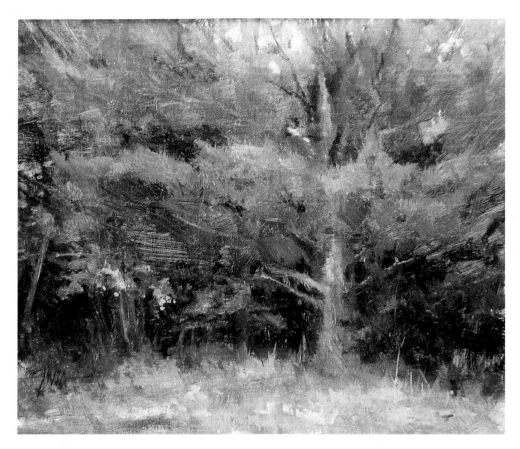

**"A WHITE PINE IN MAINE",
OIL ON LINEN, 10 x 12"
(26 x 31CM)**
Sometimes I just like to zoom up on my subject and focus on a single element. Here, I was attracted to the pine tree and the deep, rich, warm darks that set off all of those varieties of greens. Look at the transitions of color as the lightest cool green (Viridian Green plus Cobalt Blue Light, Cadmium Yellow Pale, Yellow Ochre and White) falls into shadow. Look even closer for those subtle transitions — they are beautiful.

MASTERING
COLOR MIXING

Seeing the subtle differences in color temperature was very frustrating to me until I started painting color charts. These have been invaluable in fully comprehending these nuances. I began with a palette containing warm and cool variations of red, yellow, green and blue, plus white, and painted a separate chart for each main color on my palette. Starting with a dominant color, I added each of the other warm and cool colors into that color, one at a time, and then added white to each of those two-color mixes.

Through this process, I discovered how each color and its temperature can be modified with other colors. The charts also taught me how to mix variations of colors I never thought existed. It's an exercise I've repeated several times, and one which I recommend to all artists.

BETSY DILLARD STROUD

RECORDERS OF OUR TIMES

Lynn McLain's photorealistic excursions into the landscape free him to explore his obsession with texture and the effect of light and dark as it strikes his subjects. In **"High-O-Tonto", watercolor, 20 x 30" or 51 x 76cm**, the subject is an ancient wall structure built by the Salado tribe. Depicted with trompe-l'oeil accuracy, this massive mud-rock formation looms dark and large against the atmospheric desert that plays a secondary role.

McLain's process is comprised of multi-layered transparencies, as he repeatedly glazes one transparent layer over another until he achieves the depth and richness he is looking for. McLain relies upon the watercolorist's magic trick bag for his renditions. Using salt, for example, enables him to depict an ancient wall mottled with age and history. Yet his techniques are never obvious. As a traditional watercolorist, he paints from light to dark, adding his deepest and darkest pigments at the end. The end result is a chiaroscuro that would make the old masters envious.

At the dawn of the new millenium, the landscape painter is perhaps the most accurate reporter of our time — the aesthetic recorder of myth, philosophy and fact. Visual images record our past, reveal our present and sometimes predict our future. The visual record that landscape painters provide is as insightful, meaningful and accurate as written history itself, and may contain the embryonic seeds and portents of later discoveries.

In this essay, we will look at some of the motives and goals of historical and contemporary landscape painters. Although the scope of this essay does not permit a grandiose explanation of the origins and history of landscape painting, perhaps a few brief points will encourage you to explore this fascinating subject further. Then we will touch base with seven contemporary artists who represent a cross section of styles ranging from photographic realism to lyrical abstraction: Lynn McLain, Gerald Brommer, DeLoyht-Arendt, Stephen Quiller, Ed Mell, Jean Sampson and William B. (Skip) Lawrence.

The changing face of landscape painting

According to David B. Lawall, former Director of the Art Museum at the University of Virginia, landscape painting in the modern era is quite different from that of the past. "In the fifteenth century", Lawall maintains, "landscape served as a foil to figure painting, and it is only as we approach the seventeenth century that landscape painting, as a genre, makes its appearance". He points out that a Peter Paul Rubens (1577-1640) landscape encompasses everything — perception, nature, color, space, atmosphere, time, change and human action in harmony therewith. But, he

continues, "The aesthetic climate changed, and from the Barbizon School in France to Impressionism, painters tended to isolate individual elements of nature, losing the synthesis of earlier times".

As landscape painting developed, light became the subject. This light was not the supernatural light of saints and angels, the haloes of the hallowed Renaissance or the Reformation, but natural light. The romance with natural light became, in itself, a deification.

Just as the invention of the camera represents a milestone in the development of art, the "isms" of the nineteenth century act in such a way for

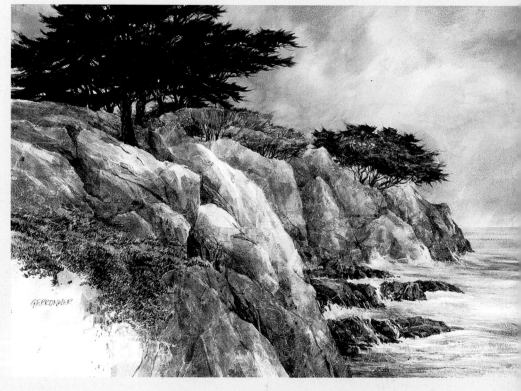

Gerald Brommer's landscapes express a more baroque moodiness created partially by the layers of collage integrated with paint, creating a multi-layered surface which is both abstract and realistic, suggestive and descriptive. His aim is to express a feeling or mood, and only when he captures that essence does he consider himself successful. For example, in **"Carmel Storm", watercolor/collage, 22 x 30" or 56 x 76cm**, a somber gray sky and a churning sea serve as a backdrop for the highly textured rocks and hillside, evoking a contemplative and anticipatory mood of the storm about to happen. Notice how texture is a secondary adjunct, but it is that amazing tactile surface that is Brommer's legacy.

Step by step, Brommer builds his painting, beginning with a watercolor in which he establishes color, value and structure. The next step involves a gradual process of integrating paint and collage, layer by layer, until he achieves the tactile beauty and structure he seeks. "My love for texture and form must come through in my painting," he states. Philosophically he adds, "In reality, what you remember from a place is the true content. People ought to ask themselves why they take a photograph, why they were drawn to a certain area. Therein you'll find the essence you are striving to depict with your painting, the content of your painting."

art. In the nineteenth century when Transcendentalism, Pantheism, and Deism ruled the day, the patronage of the church was long gone. God abandoned the pulpit and headed for the woods. God was not replaced by nature, he was nature.

In nineteenth century America, schools of landscape burgeoned. It was an age often referred to by art historians as "The Golden Age of Landscape Painting". Painters communed with nature in the forests and on the open range, their brushstrokes glorying everything from the panorama to the wooded copse. The Hudson River School and the Luminists continued the frenetic search for light. Landscape painting became the paragon for the nationalistic attitude of the government, just as the propagandistic paintings of the French Revolution symbolized that period in Europe. Painters escaped to the vanishing landscape both as meditation and as a way of preserving history for posterity.

In Europe, the romanticism of Turner and Constable ruled until mid-century, and then, Impressionism and Postimpressionism reigned. All of a sudden, there were new rules — rules that defied traditional painters' mores, rules that inflamed and excited at the same time. With Monet, time and space united to form a marriage that heretofore had not existed. Manet curved horizons and Cézanne painted from multiple perspectives. Today, the discoveries of these artists continue to inspire and influence landscape painters all over the world.

(Opposite) The work of **DeLoyht-Arendt**, a plein air veteran for more than 20 years, represents direct watercolor painting at its finest. Where other artists may offer panoramic views, **DeLoyht-Arendt** grabs you by the hand and takes you down the garden path for an intimate peek and a charming close-up of nature. "The joy of painting outdoors," she states emphatically, "is far greater than the end result".

She begins by finding a subject that excites her, and quickly does a compositional sketch. Then, she does a light contour drawing on her paper so that she can make changes along the way. "I look for various things when I select my subject," she explains. "What are the light and dark patterns? What are the textures? What is the mood of the place?" She works from big washes sprayed with water to small detail, although in **"Gone But Not Forgotten"**, **watercolor**, what appears to be a lot of detail is simply a masterful job of negative painting.

Colorado artist **Stephen Quiller** is both a plein air and a studio painter. He works in multi-media, often exploiting the effects and contrasts of both opaque and transparent paint in the same painting. Quiller's color is a metaphor for light, and he approaches space not descriptively but interpretively, using flat shapes to emphasize the two-dimensionality of the picture plane. In Quiller's paintings, the landscape is a distant plane, shimmering in various symphonies of color. In **"February Light, San Juans"**, **mixed media**, for example, when the back slope of the hill with its faint orange-red line accosts the cool blue of the forest, chroma collides and vibrates.

Painting for Quiller is not just visual. "I listen to the painting," he states, as he speaks of the dialogue between painter and painting. Emersonian in concept, Quiller's simple yet elegant statements reveal a spiritual reverence toward the landscape, where detail disappears and succumbs to form and color becomes a meditative and expressive tool.

Ed Mell's stunning portrayals of landscape embody the strength and tempestuous forces of the southwestern terrain. His dynamic landscapes, such as **"Columns of Rain", oil, 18 x 24" or 46 x 61cm**, are stark revelations of boldness and power. In this provocative landscape, the sky assumes a surrealistic monumentality, imparting a theatrical ambiguity and quality to the unfolding drama. Billowing clouds with blocky, angular edges comprise two thirds of the composition, subordinating the land underneath, unleashing an emotional feeling of uncontrollable energy. Chords of blue dominate, with only a few slivers of burnt orange in the landscape and a hint of warm in the clouds providing a contrast. Mell simplifies his landscapes, reducing the sharp, rocky landscape to its bare bones. His recognizable idiom is the repetitive use of geometric forms in both land and sky alike.

Using the process of sgraffito, (which is a process of painting and deleting by scratching through), **Jean Sampson** brings her watercolors to life, transforming them into subtle and colorful renditions of landscape. Beginning with an abstract watercolor painting or a painting that didn't work, Sampson starts her process of layering and scraping back. Over her underpainting, she applies thick linear marks in oil pastel until images emerge. Her layering process is one of addition and subtraction, for as soon as she completes a layer in oil pastel, she begins her reduction process, scraping through the paint with a nail file and other sharp instruments. The result is an electric tactility, a scintillating surface that vibrates with color and texture, as seen in **"Shore", oil pastel and watercolor, 18 x 24" or 46 x 61cm**. "I work in a fury," says Sampson, "grabbing pastels, smearing and scraping with wild abandon, until the painting takes over and challenges me to keep up with its energy".

Early in the twentieth century, the Ash Can replaced Arcadia, as painters looked into their backyards for inspiration. Modern thought, dominated by abstract concepts, prodded artists more than ever to explore interpretations rather than representational aspects of the countryside. Now, in the twenty-first century, landscape painting is a forum for emotional and expressive ways to respond to nature and to one's own psyche.

Painting landscapes today

One might think that the genre of landscape painting could become exhausted, but it holds as much appeal for artists today as ever. Although contemporary landscape painters vary widely in approach, technique and application, they seem to share a common bond — an unbridled love of nature, a desire to commune with it and a passion for expressing it. Lynn McLain explains it this way: "As a child growing up in West Texas, I was satisfied just seeing and walking around a windmill, a gnarled old fence post or a freshly plowed field. But now, as an artist, I have a visual tool to express what I feel and think about nature. My paintings are not just interpretations of what I see. They are what I deliberately add to bring the spirit of the place to the viewer. As I have become more mature in painting, I want to paint more than you or I can see. What I look for now, in addition to the beauty of everyday things, is the drama to go

with that subject".

Like McLain, most landscape painters connect with nature on a primal level, yet for each painter the instinct assumes a different shape, color and texture. For Stephen Quiller, it is the meditative and interpretive power of color to evoke the spirit of nature; for Deloyht-Arendt, it is connecting to the poetry of a place through the immediacy of her brushstroke; for Ed Mell, it is expressing the energy and power of the stark southwestern landscape through powerful design and strong contrasts; for Skip Lawrence, it is using lyrical color and atmospheric applications of paint to unite feeling and light, color and place; and for Gerald Brommer, it is inviting us into a sensory odyssey of paint and

texture to revisit an emotion. Jean Sampson calls the connection the dance between the existing object and what it calls forth from her imagination. "It is a visual expression of the struggle of new life forms, which emerge writhing into a new, recreated world. These forms, the tangible manifestations of the energy of nature, connect me to the very essence of life".

It is these provocative thoughts and ideas that characterize the spirit of landscape painters of the twenty-first century. They are faced with a world in which open space is sacrosanct, as day by day man expands and available land dwindles. Emerson wrote, "In the woods is perpetual youth." We are aware that gossamer clouds and idyllic pastures may become anachronistic visions. Perhaps this is the driving force behind our attraction to the landscape and the desire to preserve and express it. Whatever happens, landscape painters, lured by a cool breeze or an ocean wind winding its way through a grove of trees or weaving through a sand dune's path, will record, will interpret, will express. They will explore the feel of a hot sun as it illuminates a cornfield or a grove of aspen trees. And most of all, they will chase elusive light as if it were a lover. Whatever happens, the landscape painter will be there to witness and to record that which is, "Writ in water". □

In **William B. (Skip) Lawrence's** watercolor **"Straight Ahead", watercolor, 29 x 45" or 74 x 115cm**, we witness the dissolution of edge and form into color and ambiguous shapes, not unlike the work of Joseph William Mallord Turner. Space dissolves as color glides into more color, creating a lyrical expression of landscape. Inspired by a road leading to Pemaquid Point, Maine, Lawrence pulls us into a fluid world of subtle diffusions and lambent light.

His content, he says, "is based on the thrill of anticipation, the mystery of the unknown and the desire to begin". Lawrence does not search for content or for a particular scene. His landscapes come to him as remembrances of feelings and moods, intuitive responses to the resonant recollection of a color, light or mood that inspires him. Like a poet, Lawrence distills and simplifies until only the essence remains — an evocative tribute to a memory of light and color.

PAINTING LIFE'S MANY TEXTURES

Textures give a painting a wonderful touch of realism that invites viewers to take a closer look. James Toogood explains how to paint any texture — natural or man-made — in your landscape subject.

"WEBER'S", WATERCOLOR, 14½ x 21" (36 x 54CM)
Weber's is a classic American icon — the hamburger joint. I focused on the smooth and shiny reflective surfaces visible throughout the painting. Even the parking lot seemed to reflect some of the building. I think this demonstrates how delicious a contemporary landscape can be.

For the most part, our lives are made up of incidental moments in ordinary places. In my paintings, I try to depict those moments and places in such a way as to convey a sense of truth and recognition to the viewer. Thus, I believe anything can be a suitable subject for a painting. The trick is to make the painting interesting.

To that end, I focus on light, color, composition and, of course, texture. For me, texture is not merely the surface quality of a particular object, such as the roughness of a stone or the fluidity of water. Texture also results from the combination of surface, brush marks and paint. In art, the careful use of texture can transport the viewer by providing greater insight into the nature of the subject.

Knowing how much is enough

Determining the right amount of texture to include in a painting is an individual decision. At first glance, it may appear as though I throw everything but the kitchen sink into my paintings. There seems to be an enormous amount of information competing for the viewer's attention. Yet, although it may not be apparent at first, a careful editing process takes place in my paintings. Otherwise, a cacophony of disparate textures, each one screaming for your attention, would cause visual overload.

By editing, I mean finding the perfect balance of textures through

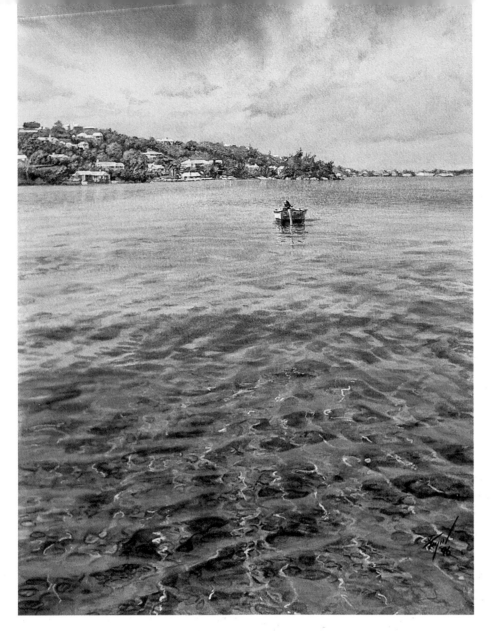

**"HARRINGTON SOUND", WATERCOLOR,
14 x 11" (36 x 28CM)**
The blue of the water is predominantly Cerulean,
a naturally opaque pigment that changes very
little from its top tone (what it looks like right
out of the tube) to its undertone (what it looks
like when highly diluted with water). I exploited
this fact by applying thin washes of color in
the background and the middle ground. Later
I scumbled a heavier layer of paint over the
foreground to create the effect not only of the
water's surface but also the undercurrents
and the bottom of the sound.

organization and simplification. First, I have to decide whether the inclusion of each particular textural element is going to help me say what I want to say about my subject. Then I also accentuate certain textures while diminishing the importance of others to vary the levels or intensities of the textures within the painting. For example, I make some of the textures very organized while painting others with a certain abandon.

In choosing which areas to minimize or simplify, I keep in mind that the contrast of light and dark decreases as distance increases due to the atmosphere, so the amount of information needed to describe a particular texture decreases as distance increases. A great technique for seeing this clearly is to squint at the subject. Squinting eliminates superfluous textures and clues me in as to which areas need simplification. Another approach is to ask myself which set of objects are least important and then unify them into a single abstract shape. Often, the contour of the abstracted shape is enough to imply a sense of the objects' texture.

Building texture into the process
I try to get a fairly good sense of where I'm going to put the most texture and where I'm going to simplify before I begin a new painting. This allows me to start building texture where it belongs right from the start.

Sometimes, the texture of a given object is integral to the subject so I take great care to include it in my initial line drawing. For example, the inclusion of lettering on a sign gives the painting a textural component over and above the surface texture of the sign itself, so the lettering should be part of the drawing.

After I'm satisfied with the drawing, I begin a series of washes to establish the basics of light and dark and the local color — the color of the object free of the influence of light or atmosphere —

"TIDAL POOL", WATERCOLOR, 20½ x 14½" (52 x 36CM)
After blocking in some areas of the underpainting, I applied a succession of heavily pigmented drops of color to create the sharp edges of the rocks. In contrast, I developed a pattern of intricate lines and softly blended shapes to create the delicate movement of water dancing in the shallows.

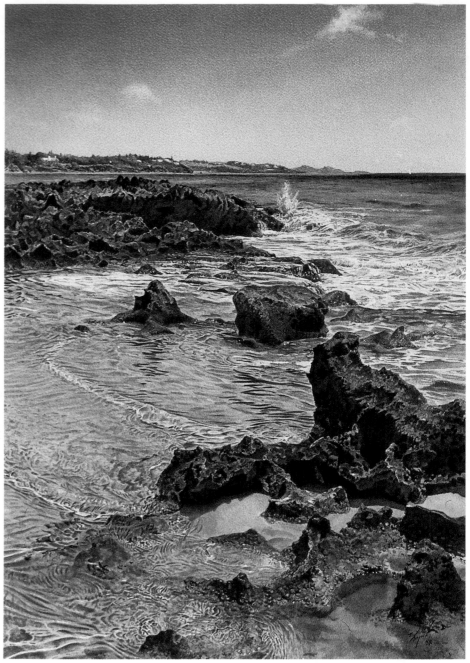

— TEXTURE TIPS —
ROUGH SURFACES

Rough textures, such as wood and rock, can be a lot of fun to do. I begin by washing in the local color over the entire object, then block in areas of light and dark to create the illusion of three-dimensional form. Then, as I continue to develop the object, I use more paint and less water in the mixture, applying it in any fashion that will suggest the object's surface, such as dripping, splashing, scraping, drybrushing or spattering. As this heavier paint dries, the pigment itself actually creates rough edges so the texture of the dried paint helps to convey the roughness of the object.

of various objects. In some cases, variations in the color and value of these initial washes will begin to suggest texture, as in the marble floor in the demonstration. I then build up layers of color, making sure each layer is dry before the next is applied. This keeps the color both clean and complex. (Please see the sidebars for more specific tips on individual textures.)

Watercolor's depth and luminosity are ideally matched to my approach. However, the use of layers and highlights can be adapted for oils or some other medium.

Transcending the boundaries
Regardless of the imagery contained within, paintings are themselves physical objects with their own specific textural elements. But painting is more than that. It is a unique language, one that transcends borders. My paintings allow me to speak about those incidental moments and ordinary places I find so fascinating so that I may communicate my feelings about the texture of contemporary life. □

**"DRIVE-IN", WATERCOLOR,
21 x 29" (54 x 74CM)**
The impact of some textures may be enhanced by painting them at a particular time of day. I felt the textures in this painting would be best seen at twilight. The soft glow of the natural light and the harshness of the man-made light portray the textures of this drive-in ice cream stand more intensely than if it had been painted at mid-day.

– TEXTURE TIPS –
REFLECTIVE SURFACES

The key to painting smooth, shiny, reflective surfaces, including glass, metal, polished stone and high-gloss paint, is to find and draw the reflections and highlights as distinct, separate passages within the overall object. This becomes more complicated when the reflection is somehow altered, for example, when distorted by the curved contours of a car. Regardless of their shape, however, I carefully draw both the object and the reflections within and then start building up layers of color, moving from light to dark. I determine and maintain the highlights from the very beginning. I then establish some areas of dark value to create contrast, which begins to give a feeling of reflectivity. As I continue to add layers, the areas that at first appeared quite dark will begin to appear lighter by comparison. This gives me the opportunity to apply even deeper darks. Throughout this process, however, I take care to maintain crisp edges where needed to define reflections and highlights while softly blending other edges to create transitions.

ART IN THE MAKING
CAPTURING MAN-MADE TEXTURES

For me, "landscape" painting includes everything from nature subjects to cityscapes, even where viewed from an interior like this one — in other words, the many environments that make up our everyday world. I chose this subject for my demo because it encompasses a variety of man-made (glass, metal, plastic) and natural (marble) textures, together in one view.

1 REFINING THE COMPOSITION
I began with a pencil drawing on my watercolor paper to work out some of the basic linear elements of the composition. At this point, some things were clearly established, while other smaller elements needed to be moved around.

2 BUILDING UP COLOR
After I'd finished defining most of the linear aspects, I applied the first washes of color. Even in this first pass, I included some variations in the colors and values to begin suggesting shape, volume and surface texture.

WHAT THE ARTIST USED

PAINTS I use an extensive palette with a wide range of paints, not only for their different chromatic effects but also for their various paint qualities. Transparency, opacity, tinting strength, staining and permanency are but a few of these characteristics.

BRUSHES I find synthetic and bristle brushes good for scrubbing and scumbling color, for instance, when painting an old, weathered building. I use sable brushes for fine detail or texture that must be carefully drawn with a brush. I prefer to use brushes no smaller in size than a No. 3 or 4. Smaller brushes don't hold enough paint for me so I have to reload too often.

SURFACE I tape and staple a piece of watercolor paper, usually 140 lb cold-press, to a board without first soaking it. If the paper buckles, I can hit it with a hairdryer to flatten it out. Even though cold-press paper itself has a bit of a texture (which can be useful in depicting some rougher textures), it isn't so rough that it impedes me from depicting smooth surfaces. I also like the way it takes repeated washes of color.

OTHER TOOLS I use a toothbrush to create specific textural effects, such as concrete, asphalt and certain types of rock. I drag my thumb across the bristles to create a spattering effect.

Masking fluid is especially useful for preserving whites, but I use it carefully because it can affect the surface of the paper. I make sure to bring the masking fluid to a natural edge, such as the edge of a building, a roof line or a figure. This way if the masking fluid does alter the texture of the paper, at least the alteration will be consistent throughout that passage of the painting and therefore undetectable.

A razor blade is a good tool for scraping off pure white highlights where needed.

3 PAVING THE WAY FOR TEXTURE

I continued layering color, working from light to dark and relating the background to the foreground. I was thinking not just about line, light and color, but also about the texture of the glass, metal, marble and plastic. Notice, for example, how I darkened the outer portions of the revolving door to create the illusion of looking through two overlapping, and thus more opaque, pieces of glass in the center.

4 USING TONAL VARIATIONS

I continued developing the exterior background, but my primary focus remained on the interior. Through subtle variations in value, I more clearly defined the stone textures in the walls, the decorative pattern along the ceiling and the sheen of the wood above the door. More obvious value variations suggested the highly reflective surface of the polished marble floor.

5 ZEROING IN

At this point, I felt satisfied with all of the textural elements, although I refined the lights and darks to help clarify the various sensations. I also cropped off a little bit of the floor in the foreground to help move your eye up to the more complex and interesting textural elements in **"Vestibule" (watercolor, 20½ x 14½" or 52 x 36cm)**.

71

"St George's",
watercolor,
14½ x 20½" (36 x 52cm)
I was fascinated by the texture
contrasts between the stone
buildings in this historic Bermuda
town and the glass, metal and
plastic of the contemporary
automobile. This painting also
shows how weather conditions can
sometimes enhance the contrast of
textures. For example, even though
the textures are seen in bright
sunshine, the beads of water from
a momentary shower are visible on
the car.

"TOBACCO BAY", WATERCOLOR, **14½ x 11½" (36 x 29CM)**
Using different techniques to achieve the white highlights on the water will result in having the light on the water dance.

"SPANISH POINT", WATERCOLOR, **14½ x 20½" (36 x 52CM)**
Clouds are the dominant textural component of this painting. To paint them, I started by painting the whole sky with a very light wash of Cadmium Lemon and Permanent Rose. I then masked off the clouds to preserve the white of the paper. For the blue sky, I used a combination of non-staining Cerulean and Cobalt Blue. After removing the masking solution, I softened the edges of the clouds by scrubbing the edges with a synthetic white sable brush.

– TEXTURE TIPS –
WATER

We've all seen how light can dance on the surface of water. I recreate the effect of sparkling light by combining four different techniques. First, I apply some little dots of masking fluid to certain areas in the water. Then I overlap several layers of paint, building up more in some areas and less in others. I make sure each layer is dry before the next layer is applied. I then remove the masking fluid with a rubber cement pick-up, revealing the white of the paper. Next I pick out points of light with a single edge razor blade in some areas and apply dots of white paint to others. When viewed, light passes through each layer of color, hits the paper and bounces back out again, allowing the colors to mix optically. Plus, each of these four techniques will react to the light differently, so as you move or your physical relationship to the painting changes, the light on the water appears to dance.

ALAN FLATTMANN

CAPTURING CHARACTER

You want your landscapes to go beyond mere description so they convey mood and evoke emotion. Alan Flattmann shows you how to use color, lighting and detail to capture the kind of character that transports your viewers to a particular place and time.

"SUMMER RAIN AT JACKSON SQUARE",
PASTEL ON GRANULAR BOARD, 30 x 40" (76 x 102CM)
The dark gray, threatening sky sets the mood for this animated French Quarter scene. The cathedral is painted very softly so that it stays in the distance and does not compete with the detailed foreground.

Whether I'm painting the landscape or any other subject matter, capturing its character is imperative to the success of my work. The French Quarter in New Orleans is one of my major ongoing themes. Every detail, from the crumbling stucco and brick walls to the decorative ironwork and wooden shutters, is fascinating to me. It is important that these paintings accurately portray the architectural heritage and distinctive character of this historic neighborhood. I see my paintings as both artistic creations and historical representations of the Quarter.

To truly capture New Orleans' character and that of other chosen subjects, I strive to make my paintings more than just photograph-like copies. First, I try to create a strong mood quality in every picture. This subjective quality instills life and energy in a painting. Secondly, I pay a great deal of attention to detail and use it judiciously to bring out the unique character of the subject.

Creating a sense of mood

Mood is both an observed and subjective quality. A rainy day mood is gray and somber. A sunny day mood is bright and cheerful. These are simple examples of the associations we make between observations and feelings. As artists, we can create whatever mood we want by orchestrating a whole range of pictorial elements and devices. These are a few of my favorite options:

Color To my way of thinking, the colors I use in a painting should be expressive and appropriate to the mood

"CAFÉ DU MONDE", PASTEL ON GRANULAR BOARD, 28 x 40" (71 x 102CM)

DETAILS MAKE THE DIFFERENCE

▲ The sunlit walls combined with the small puddles convey that refreshed feeling that comes just after a rain shower

▲ The lacy ironwork along the balcony and the horse-drawn carriage identify this scene as New Orleans

▲ Small details, like the pigeons, the striped awning and the reflections in the foreground, add interest and help develop the character of the subject

▲ The figures scattered around the scene add energy and movement

"ST. LOUIS CATHEDRAL AT DUSK",
PASTEL ON GRANULAR BOARD,
28 x 18" (71 x 46CM)

DETAILS MAKE
THE DIFFERENCE

The hazy streetlights and their ▷
sparkling reflections on the wet
flagstones add a touch of warmth
to this blustery, rainy evening

Antiquated architecture is ▷
naturally romantic

The central oval of warm ochres ▷
and browns surrounded by cooler,
darker colors poses an alluring
invitation into the scene

I'm trying to create. When painting on location, I try to duplicate the colors I observe as closely as possible. I feel this is the best way to capture the mood I experienced at that particular place and time. However, when painting in the studio from photos, I take a more subjective approach and many more liberties. I use the actual colors of a scene as a starting point, but usually alter some or all of the colors to produce a dominant mood quality. This might be as simple as changing the color of the sky

and a few objects for the sake of color harmony. Often the changes may require a lot more imagination and dramatic color alterations.

Seasons One of the best ways I have found for creating an expressive color scheme is to imagine the same scene at different seasons of the year. Specific color combinations are associated with each season. I especially love the warm and friendly rusty hues of Autumn. The subtle grays and browns of Winter, the brilliant multi-colored palette of Spring

and the saturated greens and blues of Summer also project powerful mood qualities.

Time of day and lighting Another method I have found very useful is to visualize the same subject at different times of the day and under different lighting conditions. For instance, many of the buildings I have painted in the French Quarter may look rather dull at midday, but are radiant in the warm glow of morning or evening light. The direction and source of lighting can also

be a significant factor. Simply casting an interesting shadow across a blank wall can create the drama and mystery that salvages an uninspired composition. Incandescent, fluorescent, neon and gas lights offer unusual and dramatic effects when painting the city.

Weather and atmosphere But perhaps my favorite means of creating a sense of mood in a painting is by playing meteorologist. I have often painted the same scene several times under different weather conditions, injecting each painting with an entirely different mood. I enjoy depicting all kinds of weather, but I must admit that I have a special fondness for dark, overcast, foggy and rainy days. I love the way these days provoke so many emotions and moods — feelings of tranquillity, mystery, melancholy, fear and so on. Atmospheric conditions present numerous pictorial devices for manipulating the composition. Fog, smoke and haze can create depth and unity by fusing together various elements of the picture. Rain can do the same and also produce street reflections, which offer exciting possibilities. A sunny day presents brilliant warm lights, cool shadows, billowing clouds, shimmering reflections on water and numerous other possibilities.

Attending to detail

While color and light go a long way to setting a mood for a painting, the details bring out the unique characteristics of a subject. I give them a great deal of attention in my paintings, but that does not mean I literally paint every detail. I believe it is much more interesting to use detail selectively as a means of emphasizing certain areas and conversely drawing attention away from other areas. The viewer's eyes are directed to areas that are highly detailed and allowed to relax in areas where the detail is only suggested. In most cases, it is actually more effective to simply suggest or imply detail rather than depict it in a

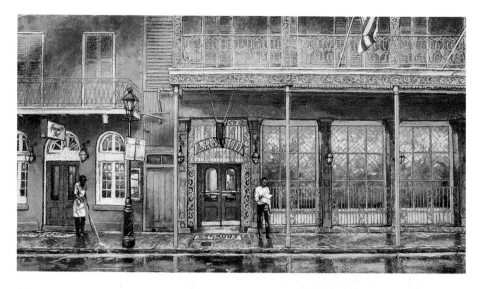

"ARNAUD'S", PASTEL ON GRANULAR BOARD, 22 x 40" (56 x 102CM)
The late afternoon sun floods this building's facade with a warm glowing light and enhances the already golden light from the windows.

meticulous way. A painting can become monotonous and very boring if detail is overdone.

There are a few keys to successfully painting details without being overly literal. For example, it's not necessary to paint every brick in a wall or every leaf in a tree. Look for the pattern of the shapes first. The brick wall is made up of a repetitive series of long, horizontal mortar lines broken by short, vertical mortar lines in a regular interval. The leaves of the tree are easily depicted with a pattern of small dots and dashes. Pick out a few bricks or leaves in a strategic area to define carefully, then let the pattern take over to suggest the remainder of the subject. No matter how complex the subject may be, it can be simplified and painted in an artistic way.

Exploring the possibilities

Capturing the character of a subject through the development of a mood and attention to detail is essential to creating exciting and distinctive paintings. As artists, we have complete control over our compositions and must remain open to all creative possibilities. □

SPECIAL NOTE FOR PASTELISTS

I hand-make these unusual speckled pastels from pastel remnants and broken pieces. This way, nothing goes to waste! I begin by separating the fragments into general color categories, then grinding them into a powder with a mortar and pestle. I then add a little rubbing alcohol to the powder on a glass palette and grind it into a stiff paste with a large palette knife. The paste is hand-formed into a ball, rolled between cardboard into a pastel shape and allowed to dry. I do this entire process in a well-ventilated area and wear protective gloves and a dust mask to avoid inhaling or absorbing the pastel dust as much as possible.

ART IN THE MAKING
BRINGING OUT THE MOOD

I have taken thousands of photographs over the years which I use for reference material to paint from in the studio. The camera does a fantastic job of recording details, but usually falls short on capturing the mood or spirit of the subject. My role as the artist is to delve beyond the obvious and bring out the subjective feelings I have for a particular subject.

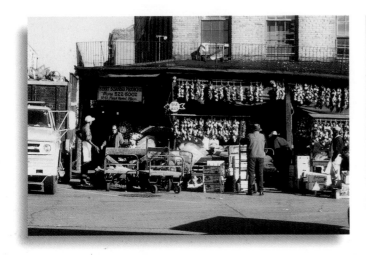

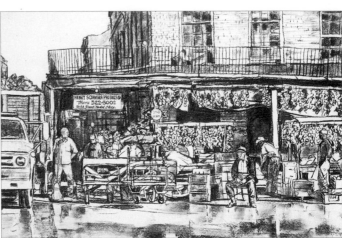

1 RECORDING HISTORY

I took this photo in 1973 when the French Market in New Orleans was a large, bustling produce market. Since then, many of the colorful stands like this one have been replaced with shops and restaurants. I'm glad I was able to record the strings of garlic and peppers hung against the brilliant red canopy that portray the strong influence of the Sicilian and Caribbean cultures on this area.

2 MAKING THE PRELIMINARY DRAWING

Using vine charcoal, I began to develop the composition in line and value without the complication of color. I liked the overall composition so I copied it fairly closely, except that I added the old man and the figure with the broom to create better focal points and more interest. I then sprayed the drawing several times with workable fixative to secure it.

WHAT THE ARTIST USED

GRANULAR BOARD I use museum rag board as my primary support — 1- or 2-ply for small pastels and 4- or 8-ply for large pastels. The ground is made of 1 part acrylic gesso, 1 part water and 1 part pumice powder. I mix these with a little acrylic color to tint the mixture a light gray or earth color. Then I apply the ground mixture to the support as evenly as possible with a foam rubber brush.

MASTER PALETTE I have hundreds of pastels, but I work primarily out of this small box which I keep restocking with my favorite colors. The pastels are broken into small pieces and the wrappers removed so that the sides of the pastels can be used to apply wide strokes of color. I use a variety of pastel types and brands — and sometimes make my own — but tend to favor the extra soft pastels that can be applied very thickly.

SPRAY PAINT I use a variety of matte finish aerosol spray paints from art and craft stores. The spray can be used to make subtle color and value alterations, as well as fog and haze effects. It also acts like a fixative to bind pigment and add tooth to the surface. However, it should only be applied as a fine mist from at least 18" away or it can ruin the pastel.

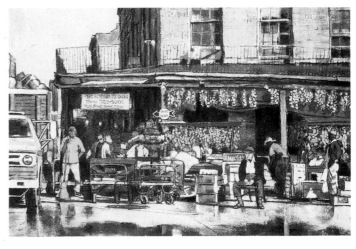

5 BLENDING AND REFINING

I gently blended the colors with an old 2"-wide bristle paint brush to even out the tones and push the color into the grain of the surface. I sprayed the painting with fixative again to make the colors more transparent and secure the first color layer. At this stage, I also refined the drawing with dark browns, greens and grays.

In this case, I liked the brilliant lighting of the photo, but felt the mood was rather bland. I decided to enhance the mood in the painting by warming the overall palette to the brown, Autumn side. Then, by adding dark street reflections and a subtle misty atmosphere, I created the feeling that a late morning shower had just passed, leaving the street and wet surfaces bright and sparkling.

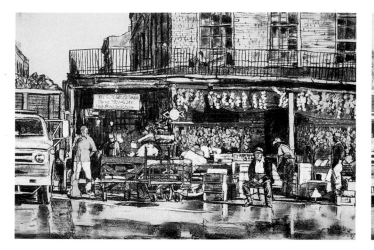

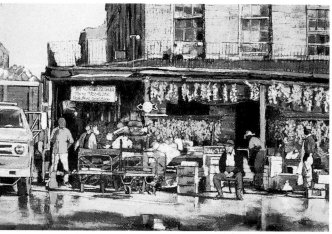

3 LAYING IN THE BRIGHTS

I laid in the brightest, most intense colors first. This immediately gave me a gauge to judge other colors by and helped create the vibrant mood I was after. Technically, it was also important to establish the intensity of the colors right away rather than trying to build them up gradually from duller colors first. That usually results in a dulling of the finished colors.

4 ESTABLISHING THE COLOR SCHEME

Using the sides of the pastels, I continued to lay in color over the remainder of the drawing to develop good color relationships and build an overall color scheme. The palette was dominated by warm browns, which are in the same friendly color family as the brilliant reds and yellows. The pale blues and cool greens served as a nice complement to the dominant warm color masses.

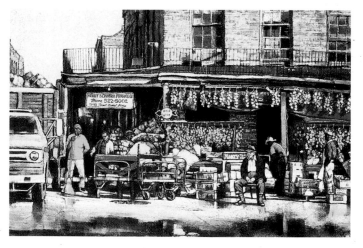

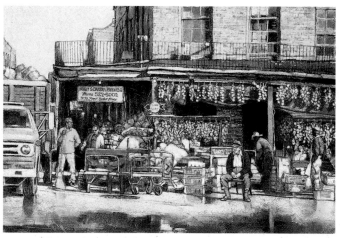

6 BUILDING UP COLOR

I began applying a much heavier layer of color to the lighter areas, using the sides of the pastels to bring out the rough texture of the granular board — a technique I call "texturing". I worked gradually into the darker areas, but tried to keep the darks as thin and transparent as possible.

I then began to pay more attention to the details. First, I refined the details within the old man and the man with the broom, but purposely kept the remaining figures more vague. Believing that the sign was particularly important in establishing character, I carefully refined the lettering with sharpened hard pastels. I also placed lettering on some of the crates and on the "one way" sign, but made them softer and more suggested. The bricks of the wall were rendered simply with random mortar lines and patches of broken color. With heavy pressure on the tips of the pastels, I reinstated the brilliant colors of the peppers and garlic. I refined their shapes a little with dark outlines of greens and browns, then put thick, light accents on some of the peppers.

7 FINISHING

I refined the figures a little more and accented the lights with thicker applications of pastel. For the finishing touches on "Henry Sciambra Produce Co." (pastel on granular board, 24 x 36" or 61 x 92cm), I used matte-finish spray paints to further develop the humid atmosphere of the scene. With a rusty red color, I finely sprayed into the street reflections and a little into the darks. Then, being very careful not to overdo it, I sprayed a light yellow over most of the light areas to soften and fuse the colors. Finally, the finished painting was sprayed again with a light application of workable fixative.

Though the finished painting has the feeling of a great deal of detail, much of it is only suggested. My ultimate aim was not to be photographic but to create a painting that reflected the unique character and spirit of the old French Market. I wanted to create a work of art that was visually inviting and aesthetically interesting.

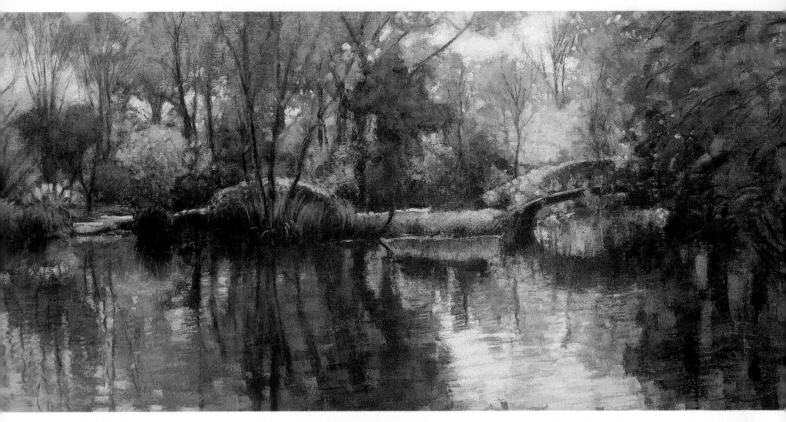

"Springtime at Mynell Gardens",
pastel on granular board,
29 x 39" (74 x 99cm)

Details make the difference

▲ The simple composition allows us to be awestruck by the wonder of nature

▲ Broad, impressionistic strokes convey the energy of a new season

▲ The vibrant colors of Spring, such as the yellow-greens, blue-greens, pinks and reds, create an exhilarating mood

▲ A warm light envelops the entire scene

"Autumn in Oxford", pastel on granular board, 24 x 32" (61 x 81cm)
I exaggerated the gold and orange tones of the town and the bright blue sky to create the revitalizing mood of a crisp Autumn day.

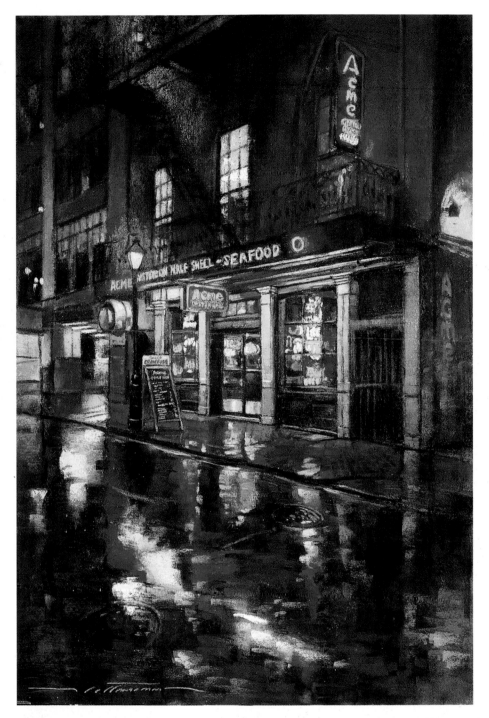

**"ACME OYSTER HOUSE AT NIGHT",
PASTEL ON GRANULAR BOARD,
30 x 20" (76 x 51CM)**
Night time and wet streets present
many dramatic possibilities. This same
restaurant and parking garage in
daylight are dull by contrast.

IDEA STARTER

Okay, so the landscape on your
easel is looking a little generic and,
well, dull. What can you do to give it
more mood and character? Here are
a few thoughts to get you started:

1 Do you want the mood to be
happy, peaceful, mysterious,
somber? Define a mood, think
of the colors that would best
express it and adjust your color
palette accordingly.

2 Do you want this painting to look
like a particular season? What
are some appropriate colors and
details that would get that point
across?

3 What time of day or evening are
you trying to paint? Think about
the angle of light and the colors
that would communicate that
message.

4 How about putting in some type
of weather or atmospheric
condition? Rain, fog, wind,
clouds — this type of detail
creates a physical sensation
in the viewer.

5 And finally, what characteristic
details could you include?
Perhaps a special kind of tree
or flower or some identifiable
object will create a unique
ambiance for your painting.
Just don't overdo the details
— suggesting is often better
than elaborately describing.

STEVE ROGERS

PAINTING REFLECTIONS IN WATER

Put more movement and vitality in your landscapes by incorporating the effects of sunlight and reflected images in water. Steve Rogers reveals his six secrets for painting dazzling reflections.

"PORTOFINO", WATERCOLOR, 28 x 40" (71 x 102cm)
I enjoy painting harbor scenes in which the dominant temperature of the colors is warm. The cool notes of sky and its reflection become the special jewels of this painting by their scarcity.

Like many landscape painters, I'm inspired by color and light. What could be more motivating than the sparkle of colorful Greek fishing boats at anchor, the mottled facade of a Venetian palazzo reflecting in an antiquated harbor or sunlight falling across the rust-stained hull of an old Chesapeake Bay skipjack? Not only am I drawn to color and light, I am taken with the irresistible movement of color and light as well. It's no surprise, then, that I often choose subjects that include water and reflections — two elements that beautifully capture these sensations.

In painting this type of subject over the years, I've discovered a host of useful tips for achieving the effects of moving color and light. I offer here my six secrets for painting reflections.

#1 Paint with honesty

The first and foremost secret is to paint with honesty. I don't try to do the camera's job of recording the facts of a place, nor do I believe that a drawing has to be totally accurate in every detail. Instead, I set out to paint a truthful representation of the scene, to paint the presence and sense of what I felt when I was there. Although I paint and sketch on location to drink in the ambiance and become familiar with my subject, most of my actual paintings are done from the thousands of slides I take and later view while painting back at my studio. Through these references, I'm able to relive the experience and my memory of the place thus becomes the painting. Naturally, I often introduce or move elements to create a stronger composition, but I always try to retain the integrity of the place and my response to it.

#2 Paint the real objects first

My second secret is to always paint the object that is being reflected before

"REFLECTIONS OF VENICE", WATERCOLOR, 28 x 40" (71 x 102CM)
Finding the warm light of a late afternoon on the Grand Canal irresistible, I hopped aboard a vaporetto, a
Venetian water-bus that operates in much the same fashion as the land-bound equivalent. It's far cheaper
than renting a gondola at $80 for a 45-minute ride, and it allows me to shoot a whole slew of great
reference photos. I think this painting really captures the jumbled wave action of the busiest stretch of the
Grand Canal near the Rialto Bridge. Despite the somewhat shallow depth of the painting, the water is still
believable because I painted the nearest waves larger than the distant waves.

painting its reflection. I can't overstate this. I have seen all sorts of curious results when this is not adhered to — shadows on boats painted as light reflections, lights painted as shadows or lost altogether, reflections of skies not corresponding in any way to the dome they are intended to mirror. I should clarify that I don't paint the top half of my painting first and afterward complete the bottom. Rather, I paint the first sky wash and then its reflection and so on, going back and forth as appropriate. The bottom line is: Never advance your painting of the water beyond your development of the object being reflected.

#3 Avoid exact duplication

This point is an important one and is often misunderstood. Generally speaking, reflections are always several shades darker and more neutral than what they reflect. But there's an exception to this rule, which I hesitate to mention because I know from teaching workshops for twenty-some years that many will misunderstand it: Only very dark objects have lighter reflections. I did not say dark objects will reflect lighter or pretty dark objects will reflect lighter, I said *very* dark objects reflect lighter.

Understanding the need to make the reflection a different value and color intensity than the actual object is paramount. Following this "secret" prevents a common problem to all composition, which is creating a painting with two equally compelling subjects. For example, think of two boats, one right side up and the other upside down, reflected in water. Painted as mirror images, the two boats will fight for dominance. Painted correctly, the limited contrast of the reflected image and its more grayed color will serve to subordinate it to the actual boat.

Another way to avoid mirror-like images is to put a little movement in the reflective surface itself. Even the calmest body of water will cause reflections to

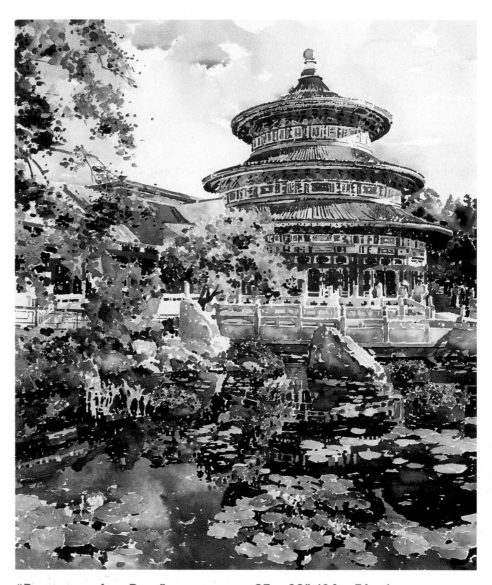

"PAGODA AND LILY POND", WATERCOLOR, 37 x 28" (94 x 71CM)
Following secret #3, I painted a believable reflection of the pagoda by making it darker and breaking the image with the flowers, rocks and lilies in the pond.

84

break up into a more abstract version of reality to some degree, further enhancing the dominance of your actual subject.

#4 Practice perspective

It's also important to understand that reflections exhibit all the properties of perspective. Just like railroad ties or telephone poles, waves — which are actually consistent in size — appear to be larger as they come closer to us or are farther down in a painting. Therefore, the reflections of objects in the water, because they depend on the "bent mirrors" of the waves, will become increasingly exaggerated as they advance down the page. Reflections of masts and pilings, for example, get "more squiggly" and even break into bits and pieces as they get closer to the viewer.

Water also exhibits a reflection of atmospheric perspective. Water, and any reflections in it, should gradually change in value and temperature as it moves into the distance. Gradation will allow water to "lie down", but without it, water will appear like a wall. Artistically, gradation has the added benefit of drawing the viewer into your composition and enhancing the sense of movement so necessary to painting convincing water.

#5 Look closely at what's reflected

My fifth secret comes from careful observation that reflections are not merely an upside down image. What we see of a boat or dock is from our perspective, but the water "sees" that object from a different and lower perspective, kind of a "duck's-eye view". Gain artistic advantage from this physical reality and paint what is actually visible in the reflection. For example, in the case of a dock or bridge, you'll probably see its dark underside reflected below.

#6 Make water look wet

Finally, the sixth secret to painting believable reflections is to make the water look wet. It's easy to think of water and sky as being soft, but in actuality, reflections should be stated with contrast to avoid a mushy appearance. Strong darks and lights are the key to achieving contrast and a wetness to the water. However, it is important to bind these contrasting elements of lights, darks and purer colors together by surrounding them with a cohesive mid-value. If the "mid-value glue" is absent, the water area of the painting will be too jumpy.

Now that you have all the secrets, I offer one word of caution. Don't over-think your painting of reflections. Use these secrets merely as a guide to assessing your efforts and improving them in the future. It's far more important to paint what you see in your heart — and not what you think you should see — so that your painting will communicate your honest vision to others. □

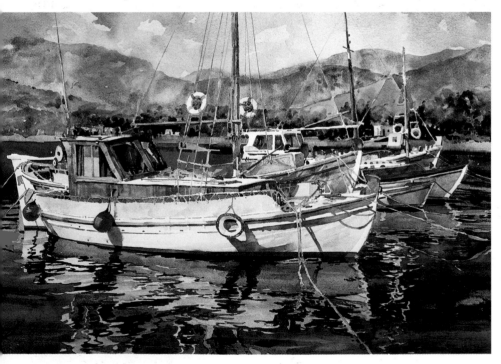

"AEGEAN BLUE", WATERCOLOR, 28 x 40" (71 x 101.5CM)
The harbor village of Aegalli is on the non-touristy Greek island of Amorgos. I'm fascinated by the grace and beauty of all Greek fishing boats. Notice the significant value change between the white boat and its reflection.

ART IN THE MAKING
REFLECTING ON WATER

Doing a painting of Venice is intimidating given the legacy of such master landscape painters as Monet, Sargent, Turner and Prendergast, all of whom made it their own. So I like to pretend Venice just sprang from the lagoon and I'm the very first artist privileged to discover it. If I still have qualms about painting here, I look at an old touristy photo of Monet and his wife covered from head to toe with pigeons in Piazza San Marco. Seeing a pigeon right atop the master's hat sure works for me!

For this demo, I chose a small canal located along the main shopping thoroughfare in Venice, the Merceria. I had noticed it on a previous trip, and I was determined to return when I knew the spring light on the canal would be glorious. Despite its rather obvious location, I couldn't find it until I remembered seeing the beautiful sign for the Trattoria Sempione. With this and my limited Italian, I was able to get directions . . . and dinner reservations. I'm not sure how we ended up with dinner reservations, but that's all part of the adventure. There's a lesson here: Whenever you're traveling, remember you're an artist and a little sketch is worth a thousand Berlitz phrases.

STEVE'S TIPS
ON WATERCOLOR PIGMENTS

When you're working in watercolor, you have to choose your pigments not only by color and temperature but also according to their density. For dark passages, I prefer to mix transparent staining pigments, such as Scarlet Lake, Permanent Rose, Aureolin, Prussian Blue, Permanent Magenta and Brown Madder (although I may float in a Cerulean Blue or Cadmium Scarlet at the very last minute, which is not recommended without adult supervision). For light and mid-value areas, I like the heavier granulating pigments — the earth colors, the cadmiums, Cerulean Blue and Manganese Blue. Using heavier pigments to create darks is a sure-fire method for making mud, while these same colors create beautiful texture and subtle grays elsewhere in the painting. Some pigments, such as Cobalt Blue and Burnt Sienna, bridge this distinction and can be used in both the lighter areas as well as in the darks.

A few other tips: Bright tube greens, such as Hookers Green or Phthalo Green, can be a real curse and easily take over a painting. I include Cobalt Turquoise and Cobalt Green on my palette as primary colors or modifiers, but both are very heavy pigments so I use them with caution. Instead, I tend to mix blues and yellows to get my greens. A cool blue (Manganese Blue) and a cool yellow (Aureolin) produce a vibrant, strong green because they're closer on the color wheel. A warm blue (French Ultramarine) and a warm yellow (New Gamboge) produce a more muted green because they're farther apart.

I also recommend keeping Raw Sienna and Yellow Ochre on your palette. I love the way Yellow Ochre can act as a subtle modifier, such as to modify a sky, throw a little reflected light into a shadow or create a grayed, muted green by combining it with a blue. Raw Sienna, when combined with various blues, is reserved for creating beautiful dark greens without the "mud" associated with Yellow Ochre.

WHAT THE ARTIST USED

PALETTE When painting outdoors, I use a small, metal, hand-held palette. In the studio, I use a larger hand-held palette with a few extra ceramic full pans added from my Dad's old palette. In both cases, I hold my palette like an oil painter. Originally, I bought the hand-held palettes for compactness and convenience while traveling, but I quickly discovered that this manner of painting forced me to paint in a more direct and immediate way. I loved the results and have been painting this way ever since, indoors or out. (By the way, I recently saw a picture of Sargent painting a watercolor of Simplon Pass. In his hand was an old palette exactly like my Dad's!)

EASELS I always stand when I paint and incline my board to a shallow angle. Indoors, I paint at a large drafting table located in my well-lit studio. In an adjacent, darkened room, I project my reference slides onto a ground glass screen and view them through a small window cut into the dividing wall. Outdoors, I paint at a French easel.

PAINTS I use a rather full palette of artist-quality watercolor pigments.

BRUSHES I paint with a 1½" Japanese Hake brush for larger washes and use a No. 12 and a No. 9 round sable for nearly everything else. I don't use any smaller brushes except a rigger to paint (can you guess?) rigging, but only if it's the type with a flat end to vary the width of the line.

PAPER I generally paint on 300lb cold-press paper that I soak and stretch. I do this even though it's ordinarily not required because I'm a fanatic. I don't like having a problem with wet granulating washes settling where they do not belong when a little effort could have prevented it.

1 DRAWING WITH HONESTY

After I had warmed up by sketching in pen and ink, I made a careful drawing from one of the many slides I had taken of this subject. I corrected for the distortion created by the camera lens, but I avoided getting out a straightedge and "constructing" a perspective study. The overly straight quality this imposes would have been out of character with the other elements of the drawing, and after all, this is Venice where nothing has been straight or plumb for centuries. Whatever the drawing may have lost in accuracy, it is more than made up for in feeling. I drew what I saw, but I also worked from my heart. I included some shading in the darker areas to give me a better sense of volume and to serve as signposts when the paint started to flow.

2 STARTING WITH A QUIET SKY

To put in the sky, which will later be reflected in the water, I painted this rather small patch with a No. 12 round sable, using Cerulean Blue and a little Permanent Rose directly on dry paper as evidenced by the little sparkle of white paper. I wanted this to be a restful area of the painting but I did not want it to be flat or too pretty. So while it was still somewhat wet, I floated a pale wash of Scarlet Lake and Yellow Ochre into it. A small blossom developed as a result. Great! It will hold together with the other areas of the painting that will contain strong texture. (If you are one of those upset by blossoms in the sky, check out the humdinger in Sargent's "Bridge of Sighs", the quintessential Venice painting.)

3 GOING OVER TO THE DARK SIDE

My next step was to establish my range of value-colors with some strong darks and intense colors so that I could paint the intermediate values and hues with more subtlety. For my darks, I used colors that were rich and very transparent, generally combinations of transparent staining pigments to avoid making mud. Normally when I work with a subject under a natural, cool light source, I paint "out-of-light" areas, such as windows and doorways, as warm darks. But since these shadowed areas fell within an area which was already warm — the pink and ochre buildings — I found it more effective to move to the cool side for contrast. I never hesitate to adjust a color's temperature or add a touch of reflected light to an area, even though it's not present in my slide, if it will benefit the painting.

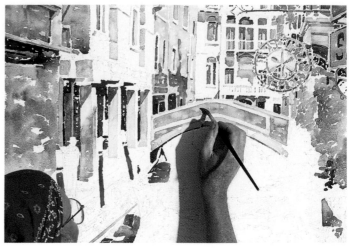

4 MIXING COLORS ON THE PAPER

I continued to develop strong colors (especially warm colors) and more darks throughout the image, compensating for the washed-out color in my reference slide. In most of these larger areas, I laid down washes of color and then floated in additional colors while the initial washes were still wet. Mixing these same pigments on my palette would have yielded a flat appearance inappropriate for the dance of sunlight I wanted to portray. Sunlight is really a combination of the direct light from the sun as well as the cool skylight, so a few cool notes in the sunlit areas effectively captured this sensation.

5 PUTTING IN SOME DETAIL

I continued developing the image, including some of the smaller details such as the Trattoria Sempione sign. Even in these smaller passages, I used a No. 9 round sable to avoid becoming too tight. For many other areas, I used another favorite, a No. 12 round. I've got to admit that by this time I was tempted to get into the reflections. But, following my own advice, I completed the parts of my scene that will be reflected before diving into the juicy water . . . of my painting, that is. It's not advisable in actual Venetian canals!

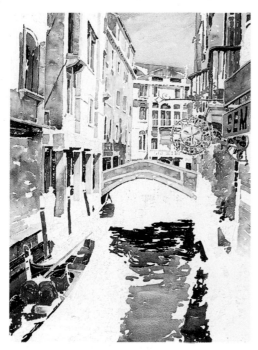

7 KEEPING THE MOVEMENT SUBTLE

I continued to paint the reflections of the buildings in darker, more neutral values than their sources. Another goal in painting these reflections was to create a real sense of this particular canal, not just a generic version. So the water here is broken in a different way than the more active reflections created by vaporetti and other larger boats in scenes of the Grand Canal. Here I wanted to convey the gentle movement of water in a quieter canal after a gondola has just passed.

6 TAKING A DIVE

The reflections at last! I painted the very dark reflection of the under side of the little ponte (bridge) first so I wouldn't "wimp out" when I came to the reflection of the sky and buildings. I painted a strong, yet still fluid, passage with nearly a full complement of transparent colors. Remembering that gradation of value or color is essential in creating a sense of movement in water, I allowed part of this passage to move to the cool side to avoid that flat feeling typical of a monotone wash. Since the reflected sky is probably the most important single passage in this painting, it needed to be painted with strength and clarity in colors that were both darker and more neutral than the sky itself. I painted a juicy wash of Cobalt Blue, Cerulean Blue and Manganese Blue, freely mixed on the paper. Then I floated a very light wash of Aureolin and just a hint of Yellow Ochre and Scarlet Lake into part of the still-wet blue wash.

8 LEAVING SOME WHITE PAPER

In the final stage of my painting, I filled in the small areas and pieces I had left, often introducing spots of warm color in cool passages or vice versa. In some cases, I left little gems of pure white paper, but to quiet other areas I used nearly the same color as the existing wash. What may be most important is what I did not paint. A watercolor sings in a very special way when white paper is allowed to dance throughout the composition. Finally, I painted the two gondoliers in an understated fashion to make them fit in with the rest of the painting.

9 MAKING A FINAL ADJUSTMENT

Before I could decide whether to pop open a bottle of champagne or cry in my beer, I had to live with the painting for a while. After placing a trial frame and mat around it, I saw that the sky needed more strength in order to relate to its reflection and to create more of a sense of light on the buildings. Using a soft Japanese hake brush that wouldn't disturb the existing layer of paint, I laid in a wash of Cobalt and Cerulean Blue, keeping this area calm to provide a rest spot in this busy painting. With this, **"Trattoria Sempione" (watercolor, 40 x 28" or 102 x 71cm)** was complete.

WHAT SHOULD I WEAR?

I paint in old clothes, neutral in color. I've tried "dressing up" for demonstrations in front of very large groups by putting on a better shirt than my traditional gray t-shirt, but I was conscious of being a bit too careful. So if the goal is to paint the best painting possible, I'll do anything to promote that, even if it means looking more like a "house painter" than an artist. I also cover my head with a bandanna when I paint. If I'm painting a warm painting I wear a red bandanna, but if my painting is cool I wear a blue bandanna. This probably does not create some special aura that penetrates my psyche but it does remind me of my goal. It's all part of my "painting costume". Just like Superman and his cape, my costume makes me feel that I can do more than the ordinary guy can do in his "civies." Does it really matter? Look at self-portraits of Rembrandt if you're not convinced!

"Limanaki Mou and Chapel", watercolor, 28 x 40" (71 x 102cm)

"Limanaki" is the diminutive for harbor in Greek and "mou" is the possessive "my". This was "my little harbor" and I walked to it twice a day for a week, painting and taking pictures at every time of day. Notice the light reflected back into the cast shadows on the sides of the boats. Nothing gives a harbor scene more sense of the dance of light and water than this effect. To achieve it, I painted a second wash over a somewhat lighter value, taking care not to overstate the difference in values. Look at how subtle this difference really is.

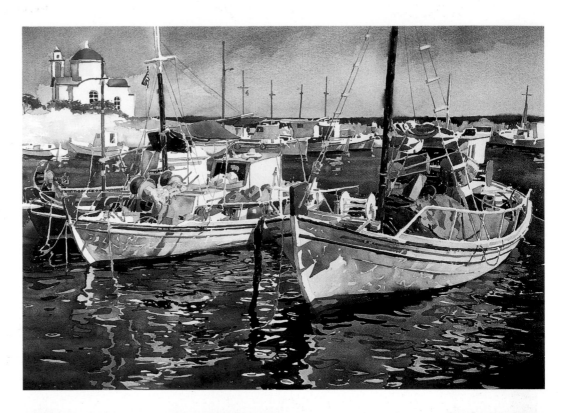

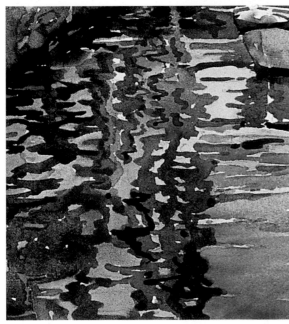

"Poste Vecchie", watercolor, 29 x 21" (74 x 54cm)

The strong warm colors so dominant in "Poste Vecchie" are painted directly with wet pigment mixed on the paper. But I wanted the reflection to be a subordinate element, so I painted the water with the same rough, spotty color so assertive in the rest of the composition. Technique can have a powerful unifying effect. Note also where I floated in a little Cerulean Blue or Cobalt Blue to modify a red or yellow. These middle-value blues are the "glue" that hold the reflection-filled water together.

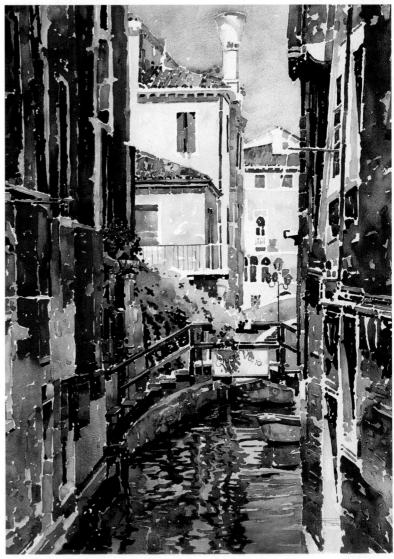

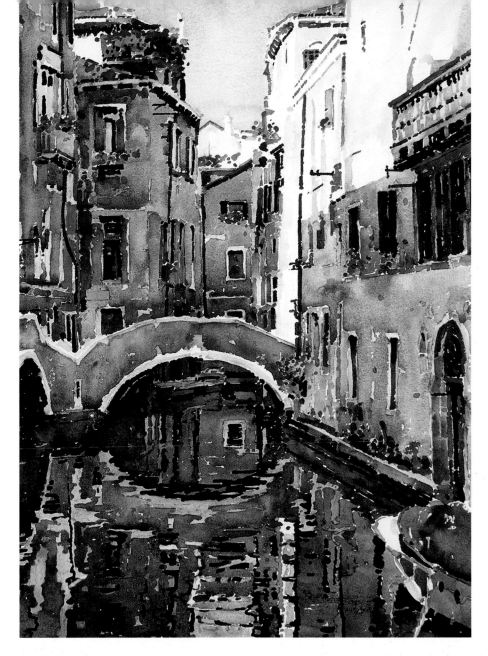

"DUE PONTI, VENICE",
WATERCOLOR, 29 x 21" (74 x 54CM)
In this more somber painting of Venice, the two bridges and their reflections combine to form the interesting ovals that repeat similar but not identical shapes. Notice that the underside of the bridge is visible in the reflection.

HOW TO PAINT
REFLECTIONS

These are my six tips for painting water with reflections in a convincing manner:

1 Paint with honesty, trying to capture the presence and sense of what you felt when you were there

2 Paint the real objects first, then the reflections

3 Avoid duplicating the object in its reflection; make it a different value (almost always darker) and a more neutral color, and break it up to suggest the movement of the water

4 Practice perspective, both linear and atmospheric, so that the water and the reflections appear to move back in space

5 Look closely at what's reflected and paint that part of the object that's really visible in the reflection

6 Make water look wet by putting in contrasts of light and dark values and tying them together with "mid-value glue"

JOHN SALMINEN

THE URBAN LANDSCAPE

Nature isn't the only source of great landscape paintings. Follow John Salminen as he takes to the streets and includes architecture and people in his landscapes.

"THE WILLIAM IRVIN, DULUTH", WATERCOLOR, 22 x 30" (56 x 76CM)
I often add a figure into a composition to provide a sense of scale. The small human form gives us a measuring stick with which to gauge the immensity of the ship.

I have always felt more comfortable designing with geometric forms than with curvilinear shapes. All of the design principles I use to give structure to my work seem to translate well into a pattern of angular, straight-edged shapes. I tend to reserve curved, organic shapes for contrast in a predominantly geometric design. So architecture is a natural subject for me. Buildings follow rules that are derived from the principles of engineering rather than the laws of nature. Delicate window detailing contrasts large, slab-like facades, the repetition of windows provides rhythm, and surface texture abounds, ranging from rough stone to reflective glass. I find limitless design possibilities, along with surprising whimsical detail, in architectural subjects.

Learning to paint cityscapes
Mastering drawing skills and understanding perspective were my first steps in learning to paint architectural subjects well. To do this, I spent countless hours working on detail studies. I kept a sketchbook in the car and, even if I only had a few minutes, I would do a quick sketch. No subject was too mundane — car tires, signs, traffic lights and countless architectural details presented me with subject matter for quick studies. While utility poles may be the blight of the American landscape, they provided a good opportunity for adding linear detail. All of this drawing gave me a wealth of possibilities for paintings.

Practicing my drawing enabled me to become familiar with the effects of light and shadow, which can be used to give a

"DUNDAS MARKET, TORONTO",
WATERCOLOR, 35 x 25" (89 x 64CM)
This is a flat composition, which can present
organizational problems. To help organize the
design, I used bright colors to direct the
viewer's eye to the center of interest, the
figures. I enjoyed the beautiful design of the
characters on the signs.

"ROYAL LOANS, CHICAGO",
WATERCOLOR, 25 x 35" (64 x 89CM)
I used atmospheric perspective to create a
sense of depth in this painting. I depicted the
objects in the distance in low contrast, while
I showed the foreground areas in greater detail
and higher contrast.

ART IN THE MAKING
PERSONALIZING A CITYSCAPE

Captivated by the contrast of light in this Portuguese street scene, I decided to shoot some photos for reference. I used the camera lens to crop the subject as I wanted. However, it took two attempts to recreate the effects of light in watercolor. Grays mixed from complements play an integral role in bringing this special quality of light to life.

1 STARTING WITH LIGHT WASHES
After drawing a rather detailed pencil drawing on my cold-pressed paper, I masked off some of the white shapes and then back-painted around the area containing the child with the wheelbarrow, which would become the center of interest. I then wet the paper and allowed the pigments to flow at will. I tried to anticipate my final color scheme and used colors that would either remain unchanged through to completion or would be altered with a complementary wash. At this point, I had established both my lightest areas and my light-middle values.

2 DEVELOPING DETAILS IN THE LIGHT
Next, I began developing details within the lightest portion of the painting. I used very transparent, closely related colors and values. I eventually intended to exploit the full range of values throughout the painting, but in this area, I wanted to suggest bright light.

WHAT THE ARTIST USED

SURFACE 140 lb cold-pressed paper

BRUSHES Mostly sable rounds

PALETTE

Cadmium Yellow	Phthalo Green	Burnt Umber
Medium	Turquoise Green	Raw Umber
Winsor Orange	Cobalt Blue	Indian Red
Winsor Red	Prussian Blue	Payne's Gray
Cadmium Red Light	Ultramarine Blue	
Alizarin Crimson	Burnt Sienna	

5 GOING FOR CONTRAST
I then completed the walls of the alley and was satisfied with the illusion of moving through the shadowed passage toward the light. Next, I put in the wheelbarrow, using my darkest value made from a mixture of Alizarin Crimson and Phthalo Green. This strongly contrasting shape seemed to lessen the importance of the child, so I knew I would need to strengthen that figure.

3 GETTING GRADUALLY DARKER
As I moved away from the center of interest, I began to use darker values. I avoided placing my darkest values adjacent to my lightest values, but rather moved from light to dark in increments. The gradual change suggests light spilling from the courtyard into the dark passage.

4 ADDING COLORFUL ACCENTS
With the details of the street and overhead planks completed, I assessed the effectiveness of the transition from light to dark, both vertically and horizontally. I also added the bright colors in the sign and awning to determine if they would draw attention away from the center of interest. Once added, I felt they were too bright, so I knew they would require modification.

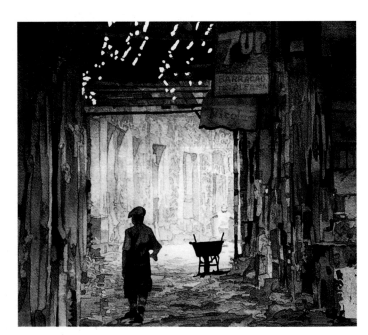

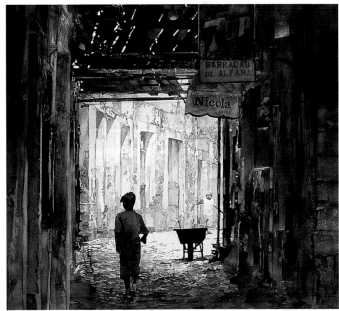

6 PAUSING TO ASSESS THE RESULTS
When I removed the masking, I added a second figure, but I was less than satisfied with the shape and gesture of it. Also, I had failed to create the effect of dappled sunlight filtering through the overhead planks. The white spots were too obviously the result of the masking technique. I was somewhat disappointed, yet I was happy with the painting's potential, so I decided to try it again in a larger format, using this 1/4-sheet as a value study.

7 REACHING A SUCCESSFUL CONCLUSION
I followed generally the same steps and techniques to create this final larger version, making a few essential changes. I altered the figure and the light pattern overhead, and adjusted the overall values by adding graduated washes moving from the darker outer edges toward the lightest area. I think this version is a better approximation of the light quality that originally drew me to this scene in **"Alfama, Portugal"** (watercolor, 32 x 36" or 81 x 92cm).

"Mastering drawing skills and understanding perspective were my first steps in learning to paint architectural subjects well."

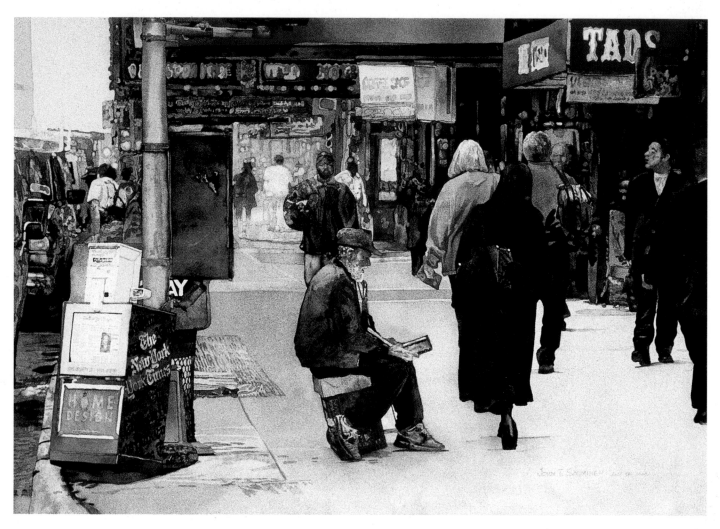

**"7TH AVENUE BEGGAR", WATERCOLOR,
25 x 35" (64 x 89CM)**
Sitting in the middle of the sidewalk soliciting
change, the beggar was consistently ignored by
the passers-by. To enhance this phenomenon,
I tried to lead the viewer's eye past him as well,
by concentrating the painting's lightest values
in the distance.

lens, which lets me zoom in and out on a scene and crop it in interesting ways.

Now I make a point of using the camera only to observe factually, and then work with paint to recreate some of the emotional impact I experienced when I initially selected the particular scene. While painting, I can manipulate value to dramatize or down-play the existing lighting. I can render some of the painting very loosely to create contrast with other, more detailed areas. I can also add figures and details not originally present in the photograph. Often I neutralize colors by adding their complements, reserving the most intense colors for the center of interest. With

this mindset, I can override the tendency to duplicate the photo reference and create a more expressive work of art.

Embracing architecture
A combination of architectural detail and figures continues to be my primary subject. Even when I choose to paint abstractions, they are clearly based on architectural images. I try to add convincing detail to a solid composition, with the inclusion of figures to help portray the human condition. I have chosen this vehicle to express a visually exciting world — one which continues to provide me with unlimited challenges and surprises. □

"CONEY ISLAND, N.Y.C.",
WATERCOLOR, 35 x 25" (89 x 64CM)
I had seriously overworked the building facade in the middle distance and needed to rescue it. To accomplish this, I used a sponge to remove as much paint as I could and then reworked the building's detail.

PERSONALIZING A SUBJECT

Creating paintings that express your emotional response requires you to break free from duplicating "the facts" in your reference material. Here are a few ways to distance yourself from your photos and personalize your landscapes and cityscapes:

1 Zoom in and out on a scene — through the camera lens or in your sketches — to crop it in more interesting ways.

2 Manipulate value to dramatize or down-play the existing lighting.

3 Render some areas very loosely and contrast them with other, more detailed areas.

4 Use your imagination or other references to add figures and details not originally present in the scene.

5 Experiment with expressive color, such as using mostly neutral colors with a few intense colors for the center of interest.

A POWERFUL DOSE OF INSPIRATION

"THE ARCHES" (1978, WATERCOLOR)
BY MORRIS J SHUBIN

I was recently asked to cite an individual painting that has had a major stylistic influence on my work. Although many paintings and painters came to mind, I chose "The Arches" by the West Coast artist Morris Shubin. Like many watercolorists, during my formative years I was trying to learn the technique necessary to begin to have some control, to be able to make the paint do what I intended. After a great deal of practice, I began to show technical improvement and the elusive medium gradually became less intimidating. I then needed to concentrate more on what I wanted to say and to begin to think about producing visually cohesive statements. That's when I turned to Shubin who uses architectural elements as a skeletal structure for his beautifully crafted designs. He also uses figures to create a sense of scale and to introduce color. As a novice watercolorist struggling to find a way to make my paintings visually cohesive, I realized that "The Arches" provided me with both a direction and a challenge.

XIAOGANG ZHU

CROSSING THE FINISH LINE

The last few strokes of every painting provide ample opportunity to make crucial enhancements. Let Xiaogang Zhu show you his way to chart a course toward a successful conclusion.

Getting a painting idea off to a good start is essential, but knowing how to finish is equally important to self-expression. In the first stages of the painting process, I work with the shapes to come up with a good composition, build an exciting pattern of light and dark values and establish a harmonious color scheme. These steps provide a solid foundation, but then it's time to wrap up the painting with a few key moves. The specific actions needed vary depending on each individual painting, but generally speaking, I work through a series of five important characteristics that I feel bring my paintings to a satisfactory finish.

1. The large masses

Once I have covered my entire surface with a very general, flat pattern of large masses of color, I stop to evaluate my progress. At this point, I consider the painting as a whole without thinking about finishing any one area. This is important because I'm looking at the relationships among the shapes, judging how well they're working together.

In particular, I examine the overall pattern of lights and darks, checking to make sure that most of my values fall in the range of medium-light to medium-dark so that my painting is neither too light and chalky nor overly dark and gloomy. I also expect to see more contrast between the shapes in and around my focal area and less contrast elsewhere. Regarding color, I evaluate the color temperatures, hues and

"SPRING CREEK, CHINA", GOUACHE, 14 x 20" (36 x 51CM)

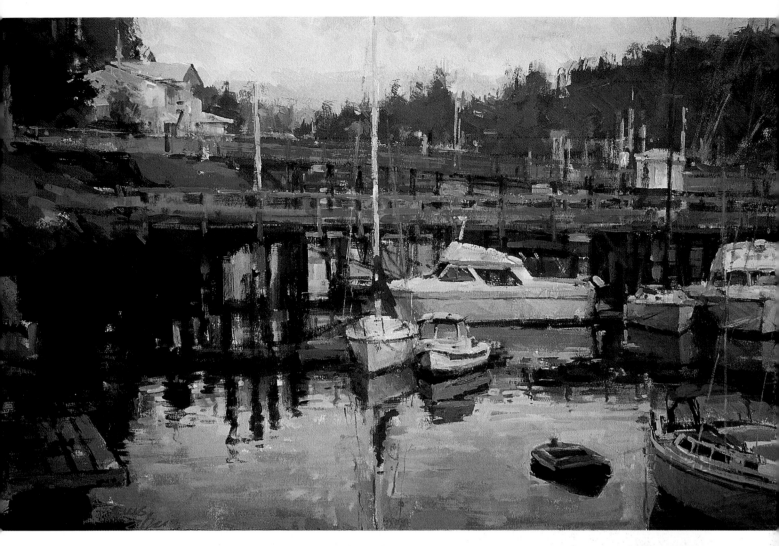

"CORNER OF FRIDAY
HARBOR", GOUACHE,
14 x 20" (36 x 51CM)

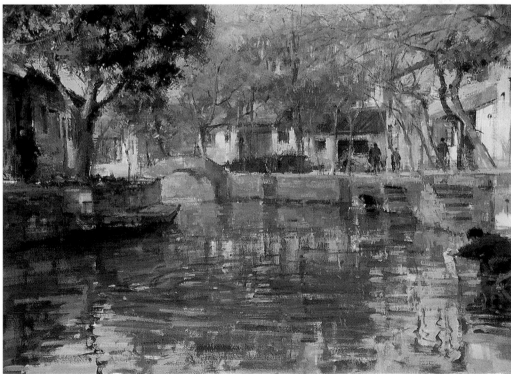

"FALL CREEK, CHINA",
GOUACHE, 16 x 24"
(41 x 61CM)

intensities, searching for harmony. I sometimes find a large shape that is too light or dark, too cool or warm, too bright or dull or simply out of step as compared to the whole. This is the time to make big adjustments or subtle modifications as needed. I generally start with the darkest shapes, then proceed to the second darkest and so on until I've addressed every mass.

As I'm doing this, I also check my large shapes in terms of drawing accuracy and make any required corrections. For example, if I have a road or river in my subject, I look at the angled contours of the shape to ensure they are in perspective and moving back in space as they should. Whether it's a building, boat or tree, I carefully check the silhouette of each shape to make sure it's correct and possesses the general character of the object.

2. Edges

Next, I turn my attention to the edges of my shapes, judging from two different viewpoints. On the one hand, I want my edges to be accurate according to how I see them. But on the other, I always remember that I may need to override whatever is technically correct in order to emphasize the focal area.

The way we see an object's edges is influenced by many factors. First, there is the object itself. Naturally, a hard-surfaced object such as a rock or a building will have much harder edges than a tree. The distance to the object also affects the sharpness of the edges. The more distant objects in my subject are more difficult to see and therefore must have softer edges than those things that are closer to my eyes. And finally, lighting becomes a factor in how we see edges. I've noticed that the edges of objects in deep shadow and in very bright light — the two ends of the

(continued on page 106)

ZHU'S GOUACHE TRICKS AND TECHNIQUES

Gouache has many diverse and appealing features. This little-used medium offers bright, opaque colors, has an attractive matte surface, cleans up easily, is odor-free, dries quickly and is inexpensive to use. But because it has its own unique ways of behaving, it takes some time and effort to learn to use it well. I've found that if you can master the following three concepts, you will handle gouache very easily.

Paint consistency or thickness

Straight from the tube, gouache paints are usually a bit too thick and dry and need a little water for good brush flow.

But knowing how much water to mix in is tricky. The mixture should be like melted ice cream in order to have opaque coverage and a bright, matte look. If the gouache paint mixture is too thin or wet, the value or color will dry darker than expected. The gouache artist should spend a lot of time experimenting to develop a feel for the perfect consistency.

Drying time

Closely related to the issue above, gouache's quick drying time is often a cause of frustration and discouragement, particularly when painting outdoors or under hot, dry conditions. Some useful solutions are: Always mix more than needed, which prolongs the drying time; keep a good spray bottle handy so you can spray an even, fine mist over the mixture before it dries completely; and, as you

apply the paint to your surface, continue adding the appropriate proportions of paint and water to your mixture to maintain the paint's consistency.

Edge transitions

Due to the fast drying time, it's easy to create hard edges where they don't belong. Try the following edge-softening techniques: Paint wet-on-wet by painting a second area while the first area is still wet. Just be sure to control the consistency of the paint and get the color right, too, as you have a brief window of opportunity to accomplish this. Or paint dry-on-dry, placing colors closely related in value and tone side-by-side to ease the transition between masses. You can also soften edges by learning to use brushes to your advantage. With an old bristle brush with very short hair, you can vary your values and edges by adjusting the amount of pressure on the brush. Or try using a soft-hair brush with fairly dry paint to feather the edges.

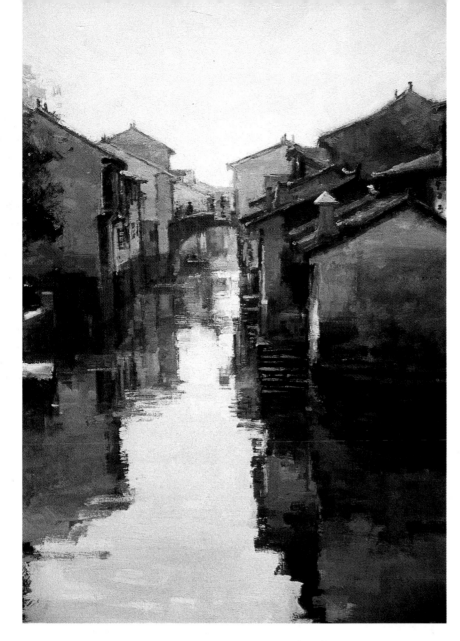

"CANAL IN BACKLIGHT,
ZHOU VILLAGE, CHINA",
GOUACHE, 22 x 16" (56 x 41CM)

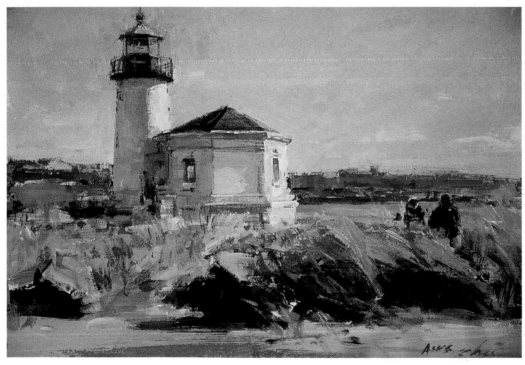

"LIGHTHOUSE, OREGON",
GOUACHE, 10 x 14"
(26 x 36CM)

ART IN THE MAKING
Bringing a landscape to a successful conclusion

This demonstration should give you a good idea of how I start loosely and then concentrate on using 5 key qualities to finish a painting so it expresses my personal vision.

1 ESTABLISHING THE SHAPES
While squinting at my subject, I roughly outlined the large, simple masses, adjusting them as I went to create a strong composition. I used a very diluted mixture of paint and kept the lines very soft.

2 WASHING IN COLOR
Starting with the most easily recognizable colors (red and blue), I began to lay in my color masses with light washes. These first two colors became my reference point for gradually developing the colors and values of the neighboring masses.

WHAT THE ARTIST USED

BRUSHES I use a variety of sizes and softnesses; I also keep and use lots of my old worn brushes to create all kinds of marks according to their odd shapes.

PAPER Hot-press watercolor paper, anything over 140 lbs.

PALETTE White porcelain butcher pan for mixing large quantities of paint.

PAINTS Any gouache brand that has good opacity.

PAINT BOX Because gouache paints squeezed onto a palette will dry before I start to use them, I use a utility nail box with sealed compartments as a paint box. I spray the paints with water as needed to maintain consistency of melted ice cream, and also lay a dampened, thick paper towel or thin sponge on top to keep moisture over the paints.

OTHER TOOLS Rag, sponge or paper towels, water jar.

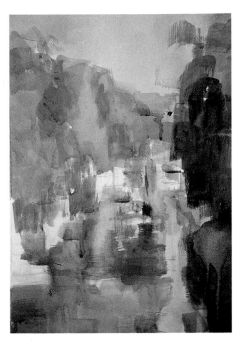

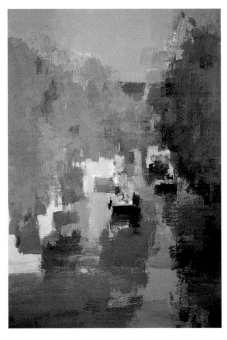

4 ADJUSTING COLOR-VALUE RELATIONSHIPS

Once again, I squinted at my subject to see the overall value pattern. Comparing that to my painting, I realized I needed to go a little darker in the lower left-hand corner. In evaluating the relationships of my colors, I recognized the need for a more intense blue in the sky and water and a duller green in the distant trees. Again starting with the darkest, most visible color, I went over the masses one by one, modifying their values and colors. In this sweep, I used a more opaque consistency and adjusted the paint mixtures' values by adding white.

3 COVERING THE SURFACE

I continued laying in my large masses of color until I'd covered the entire surface. Borrowing a technique from the watercolorists, I controlled the values in this block-in by diluting the paint with water rather than adding white. Once I had loosely roughed in all of the masses, it was time to evaluate my progress and determine how to finish the painting.

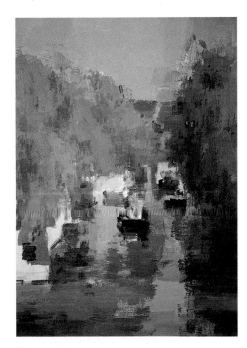

6 EMPHASIZING THE FOCAL AREA

In my final pass over the painting, I considered what changes I could make to better lead the eye into the focal area. Considering the brush stroke as the final touch, I created more texture and subtle variations within the shapes leading up to the boats as I slightly emphasized or reduced the essence of the colors. I then added more details in the boats and figures themselves, including highlights and accents. With these finishing touches in place, I felt satisfied with **"Weeping Willows Along the Canal, China" (gouache, 14 x 10" or 36 x 26cm).**

5 REFINING SHAPES AND EDGES

In my third pass over the entire painting, I began to correct and refine my drawing. I also worked on my edges, using a dry, stiff, small brush to better define and outline some edges near the boats (my focal area) but softening other edges elsewhere. I continued to evaluate the painting as a whole, not trying to finish any one area but adjusting all shapes, colors, values and edges simultaneously. Notice how an interesting surface texture began to emerge in the process of addressing these other issues.

lighting scale — become very soft, while objects in "medium" light have more well-defined edges.

But, as I said, being technically correct isn't always the best thing for the painting. Whatever area I've chosen to accentuate as my focal area should generally have the hardest edges (sometimes indicated by having the most contrast here), while everything else should be softer. If I find myself getting too caught up in accuracy, I may create a conflict. Sometimes I have to sacrifice accuracy in order to keep the emphasis on the focal area where it belongs.

3. Surface quality of the paint
The texture or tactile quality of the painting's surface is another component I like to address as I finish a painting. It's especially important as it's one of the first things viewers notice. Surface quality is, of course, very personal and can often vary from one painting to the next.

To some extent, the surface qualities of my paintings are inspired by the artists whom I've studied and admire. But I also try to allow the surface textures to emerge naturally, like a byproduct of the other efforts I'm making as I develop each painting. Eventually, however, I make a more conscious effort to play with the brush and paint, experimenting with various application techniques and creating random textures in some areas until I find something that appeals to me. It can be difficult to know when to stop to achieve the right look but ideally, the surface quality becomes a personal expression of my vision.

4. Detail at the focal area
Obviously, almost everything I've done up to this point is setting up for the focal area — the contrast of values, the harmony of color, the definition of edges and textures all support the one area I've decided to accentuate. Now I devote more time to this area by breaking it up into smaller shapes and details. I don't necessarily try to make the focal area more "realistic" with detail, but rather, I try to give it more interest through subtle variations in shapes and edges.

5. Highlights and accents

Completing the painting finally comes down to a few select strokes of very light and/or very dark paint, known as highlights and accents. These are usually placed in and around the focal point, again to draw attention to this area. Additionally, I sometimes like to place slightly bolder strokes of a very light or very dark color that lead your eye into the focal area. I make sure these additional strokes have some contrast to them but are not so overstated that they no longer fit in with their surroundings.

Checking the checklist

Finishing a painting to your satisfaction involves extremely personal decisions. Each subject has its own unique requirements, plus you have your own style, which results in color, value and detail choices unlike any others. However, I've found that running through this checklist of key qualities is very effective in guiding me toward those decisions that best support my initial concept. So the next time you're about to complete a painting, I suggest stopping to evaluate these characteristics to find the perfect ways to bring your work to a successful conclusion. □

THE FINAL STEPS CHECKLIST

Once you've got a good foundation under way, it can sometimes be difficult to know how to carry through to an exciting finish. Guide yourself through the process by asking these questions:

● In looking at my overall value pattern, do I find more contrast in and around the focal area where it belongs? Do I need to minimize the value contrast in other areas?

● How well are my colors harmonizing? Is there a color mass that needs to be adjusted because it's too bright, too dull or the wrong color temperature?

● How accurate is my drawing? Is my perspective correct? Are my silhouettes reflecting the character of my objects?

● What about the edges? Are they technically accurate? Are there any too-hard edges detracting from my focal area that I should soften?

● How's my surface quality? Do I have a balanced variety of textures to add interest, particularly near the focal area?

● Have I broken up my focal area into smaller, more interesting, varied shapes? Have I provided enough detail to add interest here?

● Could I use some touches of light-lights or dark-darks to add contrast to the focal area and lead the viewer's eye into it? Are the edges of these highlights and accents appropriate for their placement?

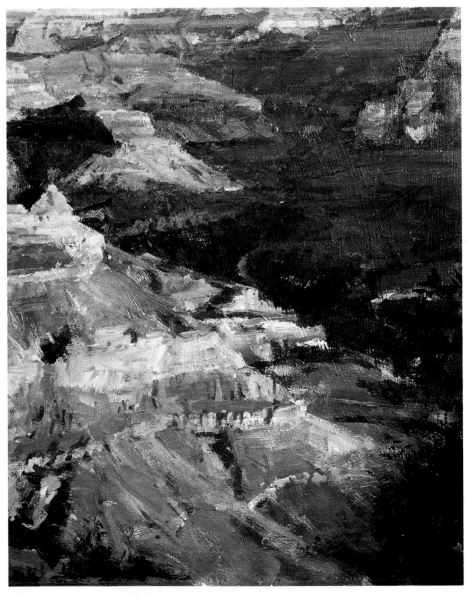

"GRAND CANYON", GOUACHE, 24 x 20" (61 x 51CM)

EVOKING THE SPIRIT OF LANDSCAPE

Be bold, be adventurous. Abstracting from nature and experimenting with materials, as Betsy Dillard Stroud explains, can bring a whole new level of creativity and distinction to your paintings.

"SEDONA SUNRISE", ACRYLIC ON ILLUSTRATION BOARD, 20 x 30" (51 x 76CM)

Deep within us are our roots. No matter where we may later go, those beginnings continue to influence us throughout our lives. I trace my love for landscape painting to my "Wood Nymph" days, as my Uncle Frank used to call them. According to him, from age two to five, I ran naked through the woods behind our house with my hip length hair streaming behind me and my mother screaming, "Betsy, get in this house and put your clothes on!"

Because I am still fascinated by my surroundings, it is the spirit of the landscape, its "heart" so to speak, that I attempt to capture. Sometimes my work is representational and sometimes it is more abstract and stylized, but in either scenario, I strive to mix paint and move brush to convey the beauty or essence of a place.

Working many ways

My approach to landscape painting differs according to four things: intention, medium, mood and surface. If I am painting en plein air, I paint directly onto the surface of the paper or canvas, and my intention is to capture the feeling, energy and essence of that moment in time. My medium of choice for plein air painting is watercolor, as it is easy to deal with in terms of hauling and setting up. Its very nature makes it a perfect medium to convey the evanescence of nature.

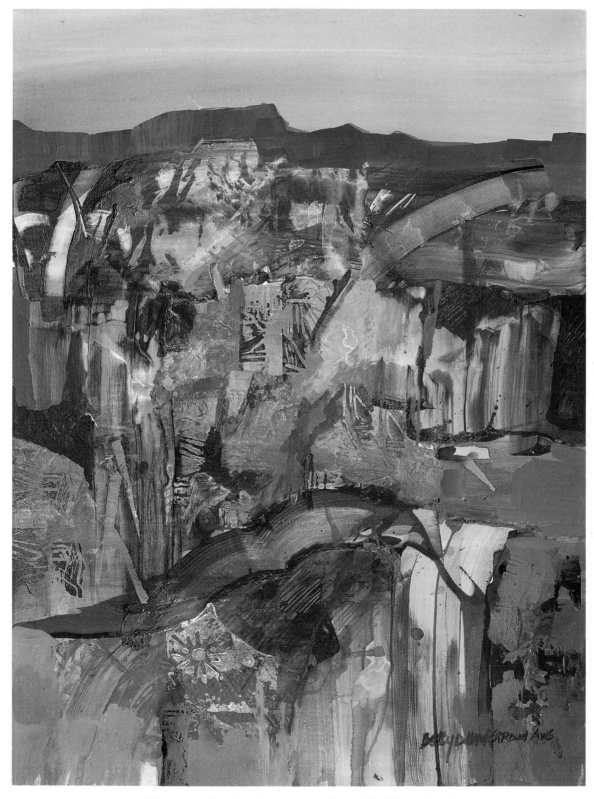

"ARIZONA MAY-DAY", ACRYLIC, 30 x 22" (76 x 56CM)

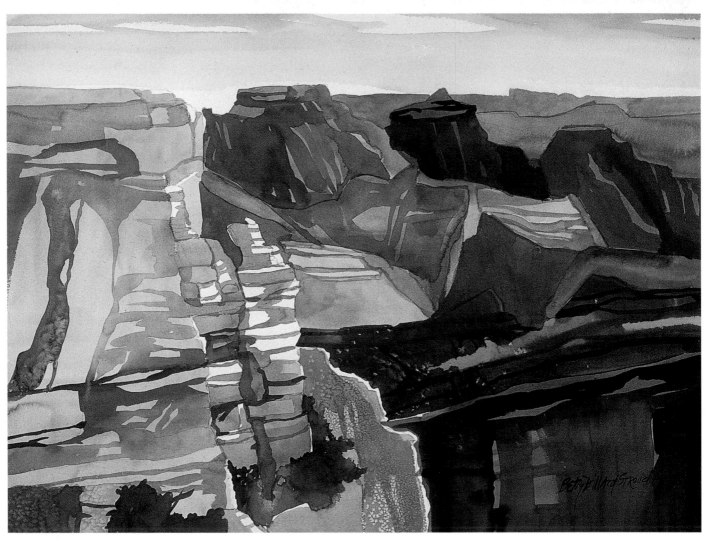

"Ode to Aaron (the Grand Canyon)", watercolor, 22 x 30" (56 x 76cm)

The more abstract landscapes are always done in the studio. Like a musical score, these acrylic renditions are all improvisations, whose color chords and compositional harmonies I compose during the painting process. These landscapes are just as real as those done en plein air because they represent the essence of bits and pieces of color and texture recorded in my memory for later expression.

Even when I speak of mood, I can mean two things — establishing a mood, such as the serenity of a sunset, or expressing my own, personal mood, which may be introspective and would suggest a more abstract, layered thoughtful painting experience. By having so many approaches and techniques, I create different challenges for myself. I am constantly changing and always searching for new ways and methods of expression.

Improvising in the studio

When I paint in the studio, I keep a full range of tools and pigments available so that I can respond spontaneously as I try to evoke the spirit of nature. Because I am a painter in love with process, most of these paintings are exploratory and experimental as I react instantaneously to the colors and textures I create. I work intuitively as long as possible, giving my subconscious carte blanche in the creative process. Simplifying, deleting and refining are my final touches. The late Robert E Wood said, "Every painting should be a surprise journey with an unexpected ending", a quotation that is my credo.

In acrylic works on paper, I may start with a textural response to the landscape. Most of these paintings begin with transparent, abstract washes to which I add textural effects by building up with modeling paste or stamping with my own personal carved linoleum stamps. Other techniques I use to decorate these initial layers — or any additional layers — are imprinting with various materials; creating patterns with poured matte medium or pigment; drawing or stamping with Titanium White and/or gesso over which I layer color; and applying a variety of acrylic media with a palette knife. I am careful to let each

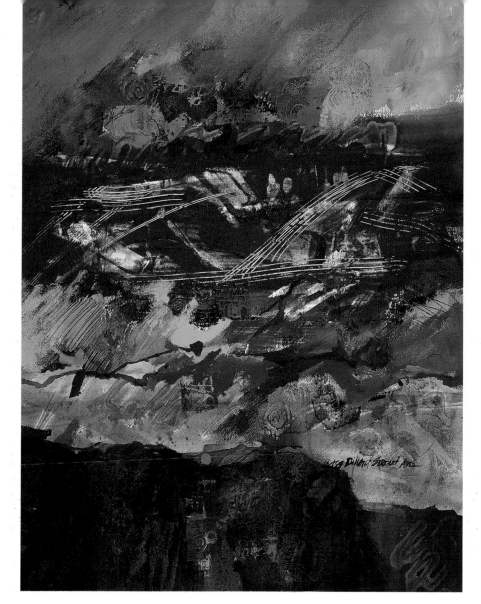

FLY THROUGH THE SKY

My skies are painted wet-into-wet and
are done quickly. My former teacher,
Naomi Brotherton, always said,
"Be out of the sky in 30 seconds
when you work in watercolor". That is
my goal — a fluid, spontaneous sky
unfettered with unnecessary brush
marks, standing in brilliant contrast
to a highly tactile landscape of
ambiguous, yet compelling textures
and colors.

layer dry before I begin the next one. Throughout this ongoing process, I play with contrasting passages of transparent and opaque paint as a foil against a highly tactile surface.

Layering and glazing are two other salient characteristics of my work. Within these layers, I often use sgraffito, meaning I scratch through the wet paint with my brush handle without abrading the surface of the paper significantly. Calligraphy is also important in my work, stemming from the many years I drew in pen and ink. I create marks by drawing into the wet paint filled with alcohol, and sometimes acrylic paint.

Texture creates mystery and ambiguity, two important components of my work. For example, petroglyphic symbols stamped into the side of a mountain create incongruity, which adds to the psychological intrigue of the work. I want the viewer to be aware that this is an interpretation of something — merely a symbol of nature or a landscape.

Pulling it together with color

While texture is certainly a hallmark of my work, color is equally important. My color choices are always interpretive and intuitive, and I am fond of working with analogous color chords and triads. Sometimes I select five to seven pigments from my box with my eyes closed and try to make a composition work. I also work with limited palettes, and love to work in a symphony of grays and neutrals, especially in watercolor. I also have my "unlimited palette" paintings, a label that makes my students laugh hysterically. With the unlimited palette, I use a glaze of one color to bring the whole painting together at the end.

After I have established an exciting surface of anywhere from two to ten layers emphasizing color and texture, I begin to create contrast with opaque paint. My opaque mixtures are often harmonious grays created from pigments used previously in the composition. I use them to paint negative space and to shape and define areas of the composition.

Almost always, I leave pieces of previous layers showing through so that by the time I finish, I have created a

(continued on page 115)

ART IN THE MAKING
Evoking the spirit of the land

My attempts at evoking the spirit of landscape are done in my studio where I have a full range of supplies at my fingertips. One of the salient characteristics of the Arizona landscape (other than its color) is its texture, and one of my primary aims is to create a scintillating surface. I keep lots of tools available, but in reality I may use only a few to make my surface tactile.

Regarding color, I used the "grays" of the desert to offset the brilliant red of the rocks and to augment the subtle greens and bleached yellows in the land and rough brush I find here.

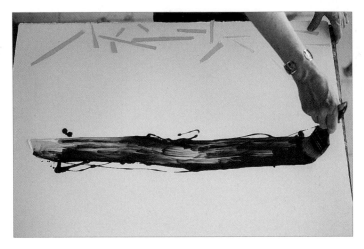

1 SQUIRTING AND TAPING
I began by applying some drafting tape at the bottom of the paper. I almost always do this to "save" areas of white just in case I might want to use them later. Now I began my initial step. Things will happen quickly! No dawdling! After pouring a dollop of fluid matte medium across the surface (which will eventually be the mountain range), I quickly squirted in the fluid Quinacridone pigments of Magenta, Gold and Transparent Red Oxide.

2 MAKING MUD
This is my favorite part, what I call the River Styx Exercise! Before the initial squirts dried (meaning very quickly), I took a big synthetic brush and "squooshed" all of the paint together. In other words, I get to make mud, and then I get to make it beautiful.

WHAT THE ARTIST USED

TUBE ACRYLICS
Phthalo Green
Red-Violet
Quinacridone Gold
Ultramarine Blue
Permanent Green Light
Napthol Crimson
Violet
Titanium White

FLUID ACRYLICS
Transparent Red Oxide
Quinacridone Burnt Orange
Quinacridone Gold
Quinacridone Magenta

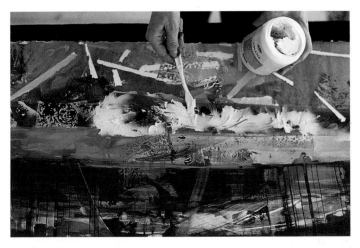

5 VOLUMIZING THE TEXTURE
Once the washes had dried, I started to apply Volume — a fast-drying, light, acrylic modeling paste — to my surface to create great texture. With a plastic palette knife, I dug into the bottle and applied the paste to the foreground where I wanted a little light and interest. I twisted and turned the knife to suggest layers of rock. As soon as it dried, I painted over it with a light wash of Transparent Red Oxide and Quinacridone Gold.

OTHER TOOLS Fluid matte medium; Volume (a modeling paste); carved linoleum stamps; drafting tape; facial tissue

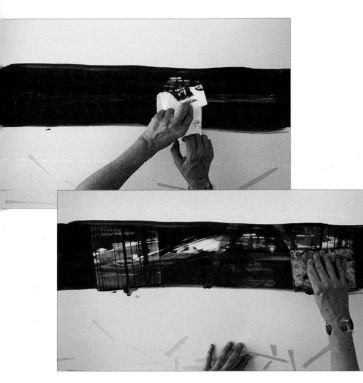

3 LIFTING OUT PATTERN

Still working very quickly, I wiped through the thick, viscous paint with facial tissue. Laying the tissue on the wet paint and lifting it rapidly makes an intricate pattern that looks like rocks. After I'd lifted with a facial tissue, I took a linoleum block and pulled it down through the paint, creating the illusion of striations. Students often gasp when they witness this procedure the first time.

4 PAINTING SKY AND LAND

Next, I mixed up separate, transparent washes of gold, violet and blue, and alternately brushed them into the sky area over the original "lifted mountains". Painting my carved linoleum stamp with Luster Green and Violet, I began to stamp at random across the bottom of the paper, which corresponds to the foreground. I also painted a horizontal swath of Violet to bring some "sky" color down into the terrain.

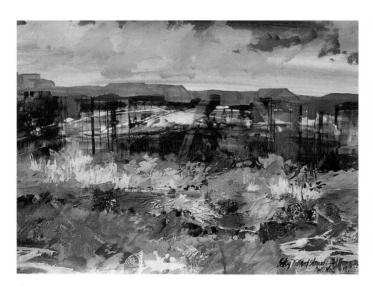

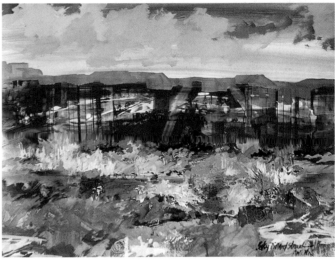

6 BRUSHING IN THE BRUSH

Mixing up some desert green from Permanent Green Light with a bit of Magenta added to it, I began to add brush shapes to the foreground, using a layered process. First, I painted the silhouette with the darkest value of the green. When that dried, I continued adding lighter values, allowing each layer to dry and making sure each layer had interesting brush work. I did this until I got the shape and value I wanted. Then, mixing up a bit of Magenta with Ultramarine Blue, I developed a distant mountain range. Finally, I added cloud formations with mixtures of Ultramarine, Magenta, Green and Titanium White scumbled over the original transparent underpainting, leaving a bit of that layer peeking through.

7 FINISHING WITH SYMBOLS

Alternating stamping and brushwork, I developed the foreground further, brushing in grayed greens, grayed magentas and painting watered down Transparent Red Oxide over the "Volume" texture. I decided not to use the design made by the drafting tape, so I simply removed it and painted over it. I also stamped into the red mountain area with my symbols and added a glaze of darker red to suggest a bit of depth. Note the petroglyphic symbols showing through the brushwork in the foreground of **"Desert Song #3" (acrylic)**.

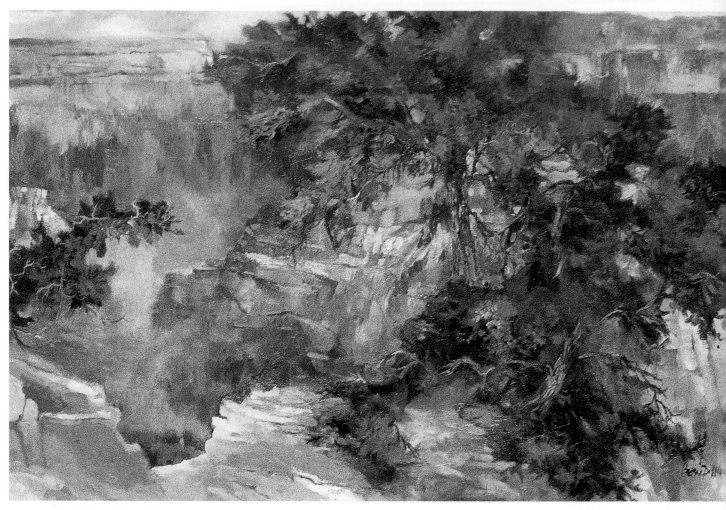

"GRAND CANYON SUITE", OIL ON CANVAS, 42 x 72" (107 x 183CM)

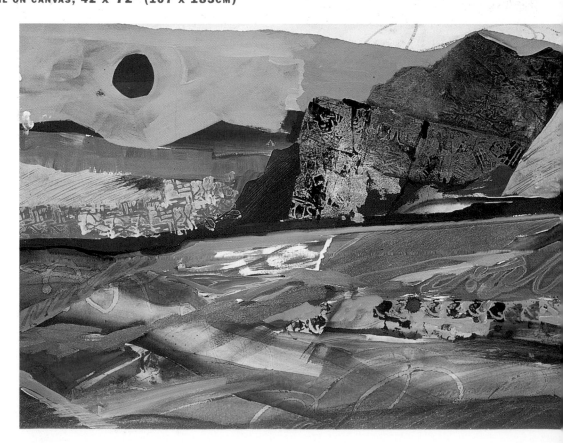

"MOON OVER SUN CITY
WEST", ACRYLIC ON PAPER,
22 x 30" (56 x 76CM)

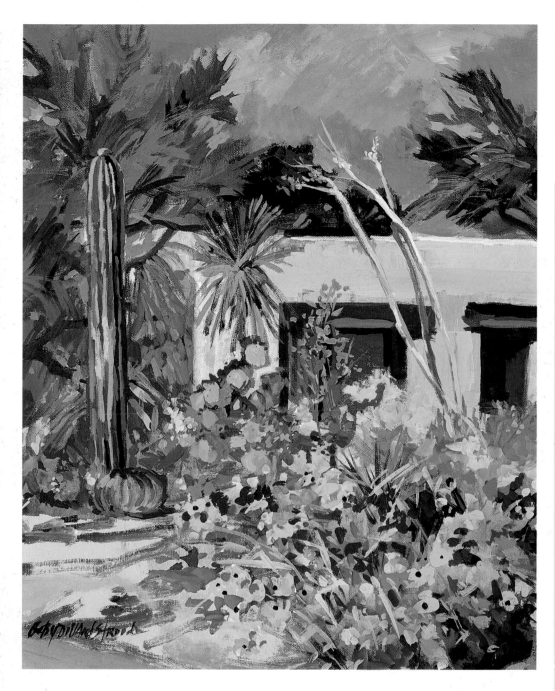

FINDING THE BEST SURFACES

Choosing a surface to paint on is really a matter of personal choice. There can be many "right" surfaces for you, depending on how and what you want to paint. My favorite surface for painting abstract landscapes is a hot-press paper or some other smooth surface especially receptive to textural effects. For direct painting in both watercolor and acrylic, I prefer 140 lb cold-press. Another favorite surface is either canvas or illustration board coated with black gesso, which creates an intriguing ambiance. On store-bought canvas, I usually add a layer or two of gesso myself, as I prefer a surface with more tooth. As with so many other aspects of painting, variety is the key to keeping things interesting for yourself and your viewers.

surface that is not only beautiful texturally but has great depth. I work quickly and intuitively until I finish the painting. Seldom do I leave the painting for another time.

Expressing joy and wonder

Years ago, when I was in graduate school at the University of Virginia, I was a rock shop junkie. I raided rock shops for tiny pieces of magnificent color and took them home to look at. My favorite piece was actually (cross my heart) a piece of dinosaur dung! Now, in Arizona, I am in Rock Heaven. The infinite shapes and the intricate combinations of stones, the sometimes subtle color contrasted with the brighter ones — the composite of colorful striations in a cross- section of rock — all provide the inspiration from which I work. In the spirit of these paintings, I become the "wood nymph" of my childhood, as I try to express that joy and wonderment from so many years ago, before the world became so complicated. In evoking the spirit of landscape, I pay homage to the shapes, forms, colors and textures in the magnificent world around me, using the world within me to say "Thank You". ❑

JOYCE PIKE

IN SEARCH OF INSPIRATION

Nothing is more energizing and motivating than an inspiring dose of plein-air painting. Even if you've never tried it before, your first trip will be a success when you head outdoors with Joyce Pike's nine tips for painting on location.

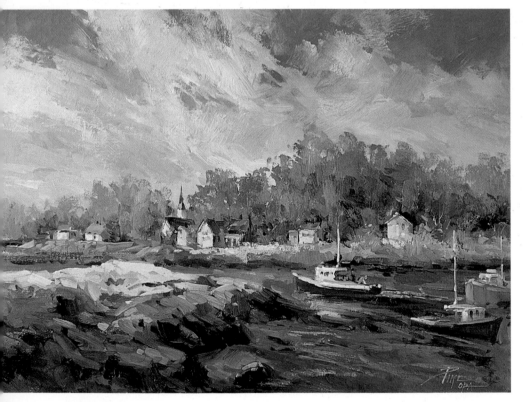

"COVE IN ROCKPORT, MASSACHUSETTS", OIL, 18 x 24" (46 x 61CM)
On a trip to the East Coast, I did several paintings of the coves made famous by many of the great eastern painters of the United States. It was really exciting to paint the strong colors of early fall in both the ocean and the fall foliage. I also enjoyed painting the eastern style fishing boats, as it was a welcome change of pace from the western style fishing boats I'm accustomed to. I can understand why so many painters are attracted to this beautiful part of the country.

For a landscape painter, nature is the ultimate resource. When I'm outdoors, enjoying the fresh air and changing light on the landscape, I reach the peak of inspiration. And that's important — I believe 90% of the success of a painting comes from inspiration.

Of course, once inspired, all landscape painters face a choice about where to create their art. Although I often work in my studio, I strongly recommend working outdoors whenever possible. Of all the great benefits of plein-air painting, perhaps the most inspiring motivator found outside is the constant flow of new ideas and subject matter. When I work in the studio, I'm often dissatisfied with the compositions I see in my photographs. Then I'm confronted with the need to change the design, but I have nothing to work with except what's there in my pictures. On the other hand, when I'm on location, I find many possible solutions, any of which can be combined, moved or altered to enhance the composition.

So have I convinced you to head outside for your next painting session? It's not as complicated as you might think. Just follow my nine tips for working outdoors, and you'll come home with a slew of fresh, exciting new paintings.

1. Pack light, pack right
Even though I have a van to cart my painting gear around in, I still believe in packing light. That way, I can leave the van behind and find the best possible painting sites.

To make it easier to carry my materials on foot, I prefer to pack my paints, turpentine and medium in a plastic fishing tackle box instead of my French easel. I put the tackle box, as well as a few other assorted items such as my palette, tissues and a trash bag, into a sturdy bag with handles. Then I pack only my brushes, knives and a few panels in my easel.

"A PATH TO THE WATER", OIL, 24 x 30" (61 x 76CM)
Walking along the beaches near my home is one of my favorite pastimes, which is why I felt inspired to paint this little pathway leading down to the ocean. The dappled pattern of sunlight and shade over the grass and trees just makes the scene that much more inviting.

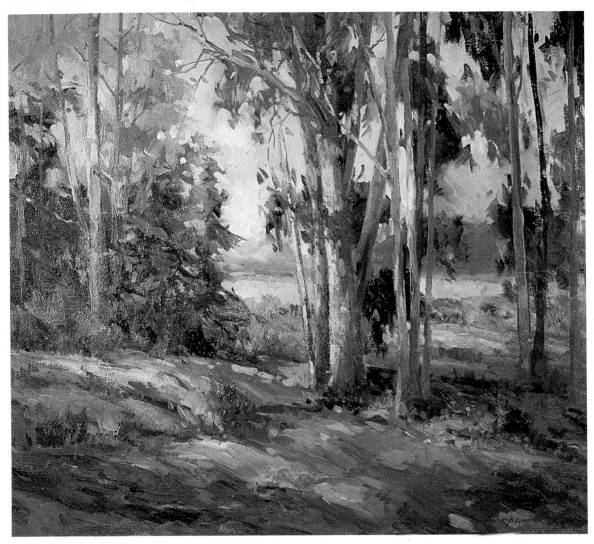

NINE STEPS TO PLEIN-AIR PERFECTION

1 Bring along only the essentials, packed so that they're easy to carry by hand

2 Learn to work quickly as the sun will dramatically alter the colors and shadows within three hours

3 Work small to save time

4 For a powerful painting, pick a subject that grabs you and keep the composition simple

5 Check the weather before you go

6 Make yourself comfortable with the right clothes, a hat, snacks, drinking water and a stool

7 Shade your painting from the sun so that your colors and values are more accurate

8 Have a camera handy for those moments when painting even a quick sketch isn't possible

9 Go with a friend — you'll have more fun!

BAD WEATHER BONUS

While bad weather conditions can make painting difficult, they can also be the inspiration for very exciting, dramatic works. If you plan to work where it's cold or windy, be sure to bring along a warm jacket. A large trash bag wrapped around your legs or pulled over your head like a poncho works well as an instant rain or wind shield.

**"THE ANTIQUE SHOP CAT",
OIL, 20 x 16" (51 x 41CM)**
I live near this little town of Cambria, California. A charming spot for painting, many of the buildings are old with lots of character. In particular, this antique shop, combined with the beautiful white flowers growing near an old picket fence, inspired a painting dripping with nostalgia. When I finished the painting, I asked my painting buddy if he had any suggestions. He recommended adding a cat, a dog or a person. I chose a cat, as it went better with the antique shop setting.

Having my materials split into two evenly weighted packages makes them easier to carry. Plus, once on site, the tackle box becomes a storage surface where I can lay my extra materials while I'm working. (Keep in mind that this system is merely a suggestion — after a few trips you'll find your own favorite way to do it.)

I've also rigged up a lightweight box with strips inside for holding my wet paintings on the ride home. I set mine up to hold the four or five small Masonite panels I usually like to bring along, but any box could be subdivided to hold several canvases in a variety of sizes.

2. Learn to work quickly
As long as I've been painting outdoors, I'm still amazed at the radical color changes that occur as the day progresses. The movement of the sun alters the scene quite dramatically over two or three hours, so I've learned to work quickly to capture a cohesive view with the same light source throughout. Occasionally, it's necessary to return to the same location on the following day in order to paint with the same light source when I'm finishing my work.

3. Work small
To help myself speed up the painting process without sacrificing on results, I find it's usually best to work in a small format, such as 8 x 10" (20 x 25cm) or 9 x 12" (23 x 31cm). These small works often come out even better than larger paintings because they have a fresh spontaneity about them. But I also take at least one large canvas, perhaps 18 x 24" (46 x 61cm) or 24 x 30" (61 x 76cm). It's always best to be prepared for the next masterpiece waiting around the corner.

4. Keep it simple
When I finally get on the road, I look for something that grabs me. Through experience, I've learned not to go out looking for something specific because I could search all day and never find it. Then again, I no longer allow myself to feel overwhelmed by the large panorama of things to paint. At first, I was tempted to put too many things in each painting, but now I know simplicity is the answer. The less I put in a painting, the easier it is to build a good composition. Often my best works are my most direct and least pre-planned.

**"CHICKENS", OIL,
20 x 16" (51 x 41CM)**
Painting in the town of Harmony,
California, I came across this
wonderful scene at the Phoenix
glass blowing studio. Thanks to
the cold weather, my hands were
getting numb so I had to work
quickly. But sometimes that's
an advantage — without a lot of
detail, the results are fresh and
spontaneous, not overworked.

**"STUDY OF DRY CREEK",
OIL, 10 x 14" (26 x 36CM)**
When I paint on location,
I sometimes like to jump right in
on a big canvas to capture the
scene before the light changes and
before my energy gives out. Then,
as a way to wind down after several
hours' worth of work, I like to paint
a small study such as this. That
may seem backwards, but it makes
sense to me.

5. Choose the right time

One thing I always do before heading out
to paint is to listen to the weather report.
This prevents me from wasting my time
going out to a location and getting set
up, then having to clean up and go home
because of extreme heat, wind or bad
weather. For me, communing with nature
and enjoying the beauty of life around us
on a good day is one of life's greatest
pleasures, but there's nothing like rough
weather to make out-of-door painting
absolutely miserable.

6. Make yourself comfortable

When I can, I like to use the back of my
van as a seat, but I also take along a
folding canvas stool. This way, I can
adjust the legs of my easel and sit down
to work when necessary. However, I still
(continued on page 123)

ART IN THE MAKING
WORKING DECISIVELY ON LOCATION

Point Lobos National Park in Monterey, California, is one of the most beautiful places on earth. I live about 2½ hours from the park, and frequent this spot for painting. Yet I never copy exactly what I see. I draw from all of the visual inspiration at the site to create the perfect composition. I also work quickly, yet deliberately, so that I can capture a fleeting moment in time.

1 PLANNING AHEAD FOR CHANGES
When painting outdoors, the light can sometimes change dramatically before I've finished the painting. Although I usually get most of the painting laid in before the light moves, I like to take an instant photograph right as I begin. This gives me something to refer to, just in case I need a record of my original light direction.

2 ESTABLISHING HUE
To begin, I toned my entire canvas with a thin turpentine wash of Cerulean Blue grayed with a touch of Cadmium Red Light. This eliminated the white canvas and quickly established the dominant hue. I then decided which part of the scene would act as my focal area. The tree area seemed a natural choice because of the dark value against the light sky and light tree trunk against the strong darks of the foliage. Using a quick line drawing, I suggested where each element would best be placed, especially the horizon.

WHAT THE ARTIST USED

BRUSHES An assortment of filberts and flats in both sable and hog bristle

MEDIUM Two parts turpenoid to one part linseed oil with a touch of damar varnish

PAINTS

Alizarin Crimson	Sap Green
Cadmium Red Light	Viridian Green
Cadmium Orange	Cerulean Blue
Indian Yellow	Phthalo Blue
Cadmium Yellow Light	Ultramarine Blue
Phthalo Yellow-Green	Ivory Black

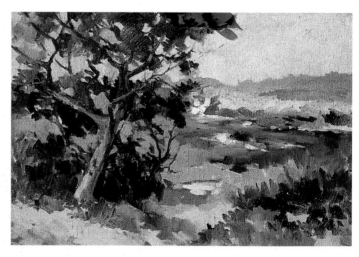

5 UNIFYING THE PAINTING
Using a variety of greens, I built up more foliage in the trees before softening and blending my blocked-in colors. Once I had tied the painting together with all areas of warm and cool, light and dark, gray and pure color, I could have walked away and called it finished. But I felt a bit more refining was needed.

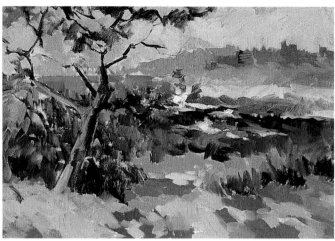

3 CREATING A PATTERN OF DARKS

Next, I established the darkest darks in the foliage of the tree and tree trunk. I also put in some cool grays to lay the foundation for a pattern of cast shadows.

4 BLOCKING IN THE REST

With my darkest values in place, I began to build up the rest of my values. I filled in the grays, going cooler in shadow and warmer in light, and added some warm tones in the bushes to break up the cools. Then I put in the water, making it much darker than it appeared because I knew I was going to work over it with a lighter value later. Note that the light-struck area in the foreground isn't as bright as the light on the headland in the distance. This will help lead the eye into the painting.

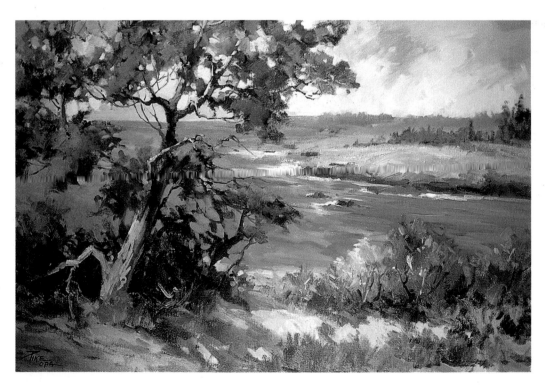

6 ADDING THE PERSONAL TOUCHES

Finishing is personal — no two painters feel the same about how far they want to go. In this case, I felt the tree needed a bit of thinning out to make a better contrasting pattern. I also wanted more light on the tree trunk against the dark foliage. The ocean needed more subtle color and all of the bushes needed a bit more color and form. These refinements made this statement — **"Near Point Lobos" (oil, 24 x 36" or 61 x 92cm)** — very personal.

"Boat in Repair",
oil, 20 x 16" (51 x 41cm)
The large hull of this boat was interesting and colorful, making it a natural point of interest. But to give the hull more importance, I had to keep all the surrounding elements understated. So I eliminated the very busy mountain, the many bushes and the strong contrasting objects behind the boat. However, I did add some color to the gray hill to strengthen the dominant hue and provide a more complete setting.

"Trees in Morro Bay",
oil, 24 x 18" (61 x 46cm)
I enjoy painting fog — the subtle shapes thrill me. I had fun arranging these eerie, ghost-like shapes into a very pleasing composition right there on the spot. To show distance, I diminished the values and used softer grays, plus a bit of green in the foreground grays. I was careful to not go too far with color because I wanted to keep the foggy look.

find standing is the best way to paint. Even when I'm sitting down to work, I occasionally stand up, step back and check my progress. I've also found it's a good idea to wear comfortable clothes and a sun hat or visor, and to bring along some water and snacks. With these simple comforts at hand, I can stay out all day.

7. Paint in the shade

It's always best to keep the painting surface out of direct sun. Too much direct light will make the colors appear brighter than they really are. Then, when taken inside, it loses contrast and color. To avoid this problem, I carry along a clamp-on umbrella (available at any drug store) to attach to my easel for those times when I can't find an evenly shaded spot to work in.

8. Have a camera handy

Time and weather don't always cooperate with artists, so sometimes I have to record a terrific subject on film and paint it later. For best results, I use slide film. Slides have good color, are easy to store and can be quickly dropped into a projector for viewing and reference.

9. Go with a friend

Last but not least, I always try to take along a friend or two, even if they aren't artists. It makes the day more fun and enjoyable, and it's safer, too. Plus, I like to get a bit of advice when I think I'm finished with a new creation. Many a painting has been saved by a little help from a fresh eye.

A little advance planning, the right materials and smart thinking on location are the perfect ingredients for a successful session of plein-air painting. And it's definitely worth the effort. As a painter who has worked both outside and in my studio for many years, I can assure you the outside work is much more memorable and enjoyable. There's nothing like being part of nature and bringing that into your art. ☐

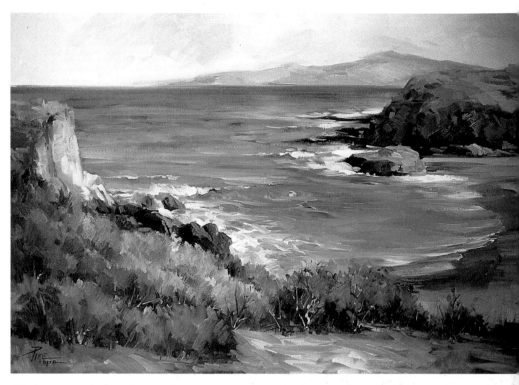

"A PLACE TO DREAM", OIL, 30 x 40" (76 x 102CM)
I live in a beautiful place by the ocean, and this spot is a favorite painting outpost called Spooner's Cove. Each season, I can see changes in the foliage that inspire me again and again. When I painted this scene, the bushes and shrubs were almost lavender.

JOYCE PIKE'S TRAVEL BAG

With experience, you'll discover which essential tools you'll need for painting on location. In the meantime, here's my list to get you started:

- Brushes in a variety of sizes and types
- Palette
- Any outdoor easel
- Medium (for oil painters) or water (for watermedia artists)
- Brush cleaning materials
- Paper towels or tissue for clean-up
- Large plastic trash bags
- Canvases or papers

ABOUT THE ARTISTS

NIKOLO BALKANSKI
pages 42 – 51

Nikolo Balkanski began painting at a very early age and graduated from the Medium Special Arts School in Sofia, Bulgaria, when he was 19. At just 21, he held his first solo exhibition of Bulgarian celebrity portraits, organized by his father. This unique show garnered a lot of attention for the young artist, and he soon continued his studies at the art academy in Sofia, specializing in painting. After moving to Finland with his parents, he studied at the University of Helsinki.

In 1981, Nikolo's portraits of a variety of Finnish figures were exhibited in a show called "Finland in Portraits", organized by the Finnish-Bulgarian Friendship Society with chairman Pekka Selvola, director of the Finnish radio. The show celebrated 1300 years of Bulgarian statehood. In 1983, Nikolo's portraits were exhibited again at the October Gallery in the United Kingdom. The London exhibition became the subject of a BBC documentary.

In 1984 and again in 1985, Nikolo was invited to Colorado to paint and to exhibit his work, but he returned to his home in Finland to exhibit his portraits and landscapes. After his relocation to Evergreen, Colorado, in 1986, Nikolo began devoting more time to painting the western US landscape, although he continues to paint portraits, still lifes and figurative works to this day.

Over the years, Nikolo has been involved in countless solo and group exhibitions, including Artists of America, Great American Artists, Artists of the West, the Buffalo Bill Invitational Art Show and Sale, the Spirit of the Great Plains and others. Among the many awards he's received are the 1995 Landscape Award from Arts for the Parks, the 1999 People's Choice Award at Impressions of the Southwest and the 1999 Collector's Choice Award at the Colorado Governor's Invitational. His works are represented in private, corporate and museum collections.

Nikolo currently lives and works in the Denver area of Colorado, although he enjoys traveling to Bulgaria, Italy, England, Finland and other European countries to paint and find new subject matter. He is represented by Saks Gallery, Denver; Taos Gallery, Taos and Scottsdale; Mountain Trail Galleries, Jackson Hole; Hayden-Hays Gallery, Colorado Springs; and Sanders Gallery, Tucson.

ALAN FLATTMANN
pages 74 – 81

Alan Flattmann has won many major awards in national painting exhibitions and received several important distinctions during his 30 years as an artist. He is a recipient of the 1996 American Artist Art Masters Award for pastel teacher, a national recognition that honors America's most outstanding and gifted artists. In 1991, he was awarded the Master Pastelist distinction by the Pastel Society of America. Recently, he won First Place for Landscape and Third Place for Portrait in the Inaugural *Pastel Artist International* Magazine Awards for World-Wide Excellence.

Flattmann's paintings have been the subject of two books, *The Poetic Realism of Alan Flattmann* and *The Art of Pastel Painting*, published by Watson-Guptil, as well as a new third book from Pelican Press entitled *Alan Flattmann's French Quarter Impressions*. His work has also been featured in many major publications. Flattmann has been listed in Who's Who in American Art since 1981.

The artist was born in New Orleans in 1946. He studied at the John McCrady Art School on a New Orleans Art Association scholarship, and won an internationally competitive grant from the Elizabeth T. Greenshields Foundation of Canada. His work can be found in hundreds of private and corporate collections, as well as the New Orleans Museum of Art, Ogden Museum of Southern Art, Meriden Arts Association, Oklahoma Art Center, Longview Museum of Art, Mississippi Museum of Art and the Lauren Rogers Museum of Art.

Flattmann began teaching painting classes at the John McCrady Art School in 1967. Since the close of the school in 1983, he has continued to teach painting workshops for art groups around the United States and abroad. He is a founding member and current president of the Degas Pastel Society, and an active member of the Pastel Society of America and the Southeastern Pastel Society.

He is currently represented by the Bryant Galleries in both Jackson, Mississippi, and New Orleans, Louisiana. For more information, visit: www.bryantgalleries.com

DEAN MITCHELL
pages 32 – 41

Dean Mitchell grew up in the small, rural community of Quincy, Florida, where he was encouraged by his mother, grandmother and high school art teacher to pursue his interest in art. The sale of his earliest works, along with competition prize money, scholarships and grants, provided the means for Dean to further his education at the Columbus College of Art and Design in Columbus, Ohio. But feeling the need to acquire "practical" career skills, he majored in commercial art rather than fine art.

Nevertheless, in his senior year, he entered his first submission to the prestigious American Watercolor Society show and was accepted on his very first try.

After graduating, Dean went to work as a commercial artist for a greeting card company, but continued to pursue fine art on the side. At 23, he was accepted into the National Watercolor Society, and at 28 was recognized as an American Watercolor Society signature member. Since that time, Dean has given up his commercial art career and now devotes himself to painting full time in his Overland Park, Kansas, studio.

In the early years of his fine art career, Dean made a commitment to enter competitions as a means of gaining exposure, even when he could barely scrape the entry fees together. His efforts came to fruition when he spent the last $300 in his checking account to enter the T H Saunders exhibit in London where he was awarded Best of Show — a pivotal moment. He's gone on to win the coveted $50,000 Grand Prize from Arts for the Parks (2000), as well as numerous other awards.

Now an internationally acclaimed artist, Dean is represented by many galleries across the US.

JOYCE PIKE

A native of San Fernando, California, Joyce Pike began formal art studies with Sери Bongart

at the age of 23, continuing later with Viona Ann Kendall and Hal Reed. She taught art for 17 years at Los Angeles Valley College and the Art League of Los Angeles. She now teaches at the Scottsdale Artists' School in Arizona. For the past several years, Joyce has demonstrated and lectured throughout Europe on the impressionistic approach to visual art, and has appeared in more than 50 television programs on art. In 1980, she won the Notable Americans Award. Joyce is the author of *Painting Floral Still Lifes, Painting Flowers with Joyce Pike* and *Oil Painting: A Direct Approach*, as well as 48 one-hour instructional videotapes covering everything from florals to seascapes to landscapes and portraits.

Joyce is affiliated with many professional organizations. She is a Master Signature Member of Oil Painters of America, the American Portrait Society, the American Artists Professional League and a Signature Member of the California Art Club, just to name a few. Her work is exhibited in eight galleries from California to Ohio.

JOHN POTOTSCHNIK

As a young college-aged man majoring in business administration, John Pototschnik felt very unsatisfied. Based on his entrance tests, John's school counselor suggested taking a few courses that involved working with his hands. John soon discovered he loved art, and decided to become an art major specializing in commercial art. He dreamed of becoming an illustrator like his heroes of the time — Bob Peak, Bernie Fuchs and Mark English.

Upon graduating from Wichita State University with a Bachelor of Fine Arts degree in advertising design, John accepted a commission as a 2nd Lieutenant in the Air Force. He spent the following four years serving as a communications officer in California, where he was able to attend

night school at the Art Center College in Pasadena.

After leaving the Air Force in 1972, John moved to Dallas with his wife and began freelancing as an illustrator. During the next 10 years, he noticed many illustrators leaving the field for careers in fine art, which gave him the courage to make the leap in 1982. In 1993, John was able to further his art education when he won the Steven Jones Fellowship, which allowed him to study human anatomy for several months at the Lyme Academy of Fine Arts in Old Lyme, Connecticut.

John considers himself fortunate and honored to have won many awards, including earning a signature membership in the Oil Painters of America. His work has appeared in several important art magazines in the US, as well as two books, *The Best of Portrait Painting* and *200 Great Painting Ideas for Artists*.

Currently, John and his wife Marcia live in Wylie, Texas, and they have two grown sons, Jonathan and Andrew. He is represented in the US by: American Legacy Gallery, Kansas City, Missouri; G. Stanton Gallery, Dallas, Texas; and Scotch Mist Gallery, Tucson, Arizona.

STEVE ROGERS

Born in New York City, Steve Rogers grew up with art. His father, Henry Rogers, was a commercial artist who would often paint at

home when Steve was a child. Steve went on to attend Rollins College in Winter Park, Florida, and graduated with a Bachelor of Arts degree from Monmouth College in Monmouth, Illinois, in 1969. Later, he continued his studies with artist Harold Stevenson and watercolor painter and instructor Robert E. Wood.

Steve has made a career of painting since 1975. Currently, he lives in Ormond Beach, Florida, with his wife Janet. They are both Signature Members of the Florida Watercolor Society, and Steve is also a Signature Member of the American Watercolor Society and the National Watercolor Society. This is the fourth year in a row that Steve's paintings have been included in the American Watercolor Society International Exhibition, and three of these paintings have received AWS awards. It is also the third year in a row that his paintings have been included in the National Watercolor Society Annual Exhibition, from which he has received one award. In addition to exhibiting with these prestigious watercolor societies, Steve has had a number of solo exhibitions throughout Florida.

Steve's work is represented in many public collections, including the Florida Senate Collection; The Orlando Civic Center; the Ocean Center Convention Center, Daytona Beach; the Orlando International Airport; the Museum of Arts and Sciences, Daytona Beach; and the United States Fifth District Courthouse. Corporate collections at Walt Disney World in Orlando, Florida, include 18 of Steve's paintings, while Euro-Disney in Paris holds 16 of his works. Steve's work is also included in collections at AT&T, Anderson Consulting and Florida Gas — Continental Resources among many others.

Besides being an accomplished painter, Steve is also an excellent teacher. He's written articles for a number of art magazines and contributed a chapter to *The One Hour Watercolorist* (North Light). As part of his teaching experience, Steve led a group of students to Greece for the first time in 1992, and he's returned to Greece and Italy several times since. These experiences have had a profound impact on the color, the sense of light and place and the overall direction of his painting. Says Steve, "I paint the light, which is a reflection of God's beauty, and it makes my work as an artist both joyful and rewarding". ("God is light" — I John 1:5.)

JOHN SALMINEN
pages 92 – 99

John Salminen holds a Masters Degree in Art Education from the University of Minnesota, Duluth. He is a Signature Member of the National Watercolor Society, the American Watercolor Society, the Watercolor USA Honor Society and the Midwest Watercolor Society. Additionally, he has been honored with "Master" status in the Midwest Watercolor Society and has earned the American Watercolor Society's Dolphin Fellowship.

Among the numerous national awards John has won are the AWS Silver Medal of Honor in 1998 and the AWS High Winds Medal in 1997, 1999 and 2001. He won the NWS Patron's Award in 1997, the Winsor and Newton Award and Plaque in 1999 and the Skyledge First Place Award at the MWS exhibition in 2000. John served as the Invited Juror of Selection for the AWS 2000 exhibition.

John's work has been exhibited in the National Academy in New York, among many other venues. It has also been featured in several national and international magazines and in many books. He is represented by galleries in Mississippi, Louisiana, Minnesota and Washington, DC.

MATT SMITH
pages 14 – 23

Matt Smith was born in Kansas City, Missouri, in 1960. When he was very young, he and his family moved to Scottsdale, Arizona. During his elementary school years, the family spent two years in Toulouse, France, where Matt attended French schools. When he was in high school, the family relocated again and lived for a year in Geneva, Switzerland. His travels in these and various other countries, including Italy, Germany, Austria and Spain, exposed him to the work of many great master artists. This stimulated his interest in art and was a contributing factor in what was to become his lifelong commitment to painting. In 1985, Matt graduated from Arizona State University with a Bachelor of Fine Arts degree in painting.

Each year, Matt spends four to six months traveling. This enables him to paint landscapes from direct observation during all seasons, and this connection to actual subjects reinforces both his plein-air and studio work.

Matt has received prestigious recognition for his work, including the Robert Lougheed Award at the Prix de West Show, the Red Smith Award from the National Museum of Wildlife Art, and both Best of Show and Artistic Merit Awards at the Western Rendezvous of Art. Each of these awards resulted from direct voting by fellow artists participating in the shows.

Matt has presented one-man shows in Arizona, New Mexico, Wyoming, Colorado and Texas, and he has participated in numerous group shows, including the Prix de West, Artists of America, Western Rendezvous of Art and the American Masters show at the Autry Museum. His work has been featured in many publications, including *International Artist*. Matt teaches several workshops a year

and serves on the Board of Directors of the Scottsdale Artists' School.

He lives and maintains his studio in Scottsdale, Arizona.

BETSY DILLARD STROUD
pages 60 – 65 and 108 – 115

Betsy Dillard Stroud began painting at the age of eight when an insightful uncle gave her a set of oil paints. She soon began lessons with a private tutor who introduced her to the rudiments of painting. A born Virginian, Stroud received her BA in art from Radford College and her MA in art history from the University of Virginia, where she also completed all course work and her orals for the doctorate in art history. Life changes brought her to Arizona in 1996, where the spirit of her early beginnings combined with the coloristic experiences of the southwest continue to influence and shape her work.

Stroud has won 22 awards in regional and national competitions. She is a Signature Member of the American Watercolor Society, from which she has also won a High Winds Medal. In addition, she is a Signature Member of The National Watercolor Society, the Rocky Mountain National Honor Society and the Arizona Watercolor Association, with which she is a Royal Scorpion and Life Member. She is also a former president of the Southwestern Watercolor Society.

Betsy has had 22 one-woman exhibitions of her work, including one at the Phoenix Museum of History. She has also exhibited in over 150 national, regional, local and state shows. She is a highly respected workshop teacher and juror known on a national level, and can also be found teaching part-time at the Scottsdale Artists' School.

A professional writer as well as an artist, Stroud contributes frequently to many art magazines, including *International Artist* for which she served as Associate Editor of North America. She is the author of *Painting from the Inside Out*, a book about her own painting theories and techniques.

Betsy's work can be found in the Roberts Gallery, Carefree, Arizona; the Milagro Gallery, Tucson, Arizona; and the Courtyard Gallery, New Buffalo, Michigan. She lives in Scottsdale, Arizona, with her two bad dogs, Scalawag and Edgar.

GABOR SVAGRIK
pages 24 – 31

Born in Hungary in 1970, Gabor Svagrik has lived in the United States since 1983. He graduated from the American Academy of Art in Chicago, where he studied with the renowned watercolorist Irving Shapiro. He's also studied privately with Scott Burdick, Matt Smith and Robert Moore.

Over the last several years, Gabor has exhibited across the United States, both in one-person shows and group shows, such as the Oil Painters of America. His award-winning works are now included in numerous private collections. Articles about his work have appeared in *Southwest Art* and *Art Talk*.

Gabor, who currently lives in Lake Zurich, Illinois, is represented by: Mountain Trails, Santa Fe, New Mexico; Long Gallery, Scottsdale, Arizona; El Presidio Gallery, Tucson, Arizona; Gallery Americana, Carmel, California; Concetta D Gallery, Albuquerque, New Mexico; Ottinger Gallery, Chicago, Illinois; and the Palette & Chisel Gallery, Galena, Illinois. You can see more of Gabor's work at www.svagrikfineart.com

TIMOTHY R THIES
pages 52 – 59

Timothy R Thies has traveled and painted throughout New England, Europe, Colorado and Vermont, drawn to each place by the promise of magic found in the rich subtleties of color and light. "I seek to capture rare moments of beauty — the light and contrast of a landscape, the anatomy of a maple tree, the colors in a still life arrangement or the patterns of light gently touching my model's face," says the artist.

Tim's painting career began in 1981 when he accepted a scholarship to study with Nelson Shanks at the National Academy of Design in New York. In 1997, he received a rare invitation to join Richard Schmid's painting group in Loveland, Colorado. Tim has also studied with Clyde Aspevig, David Leffel, Daniel Greene, Len Chmiel and many other noted artists.

Over the years, Tim has earned many awards for his work. Some recent highlights include winning the Best of Show-Founder's Award at The Bennington Center for the Arts' national juried show "Impressions of New England" and the Grand Prize Award in a national floral competition. His paintings have also been featured in leading magazines including *International Artist*.

Tim's paintings have been exhibited at The Fourth Annual Boston Fine Art Show, The Attleboro Museum in Massachusetts, The Harvard Club of Boston, The Copley Society of Boston, Southern Vermont Arts Center, The

Colorado Governor's Invitational Show and The Bennington Center for the Arts, to name a few. His paintings are in the collections of The Cape Museum of Fine Art, Chrysler Corp., W.L. Gore and Assoc., The Bio-Electric Company, The Hollister Corporation and The Bennington Center for the Arts, among others.

Currently Tim is represented by The Christina Gallery, Edgartown, Massachusetts; The Greenhouse Gallery of Fine Art, San Antonio, Texas; Nicholas Gallery, Billings, Montana; Ernest Fuller Fine Art, Denver, Colorado; and West Wind Fine Art in Manchester Center, Vermont.

JAMES TOOGOOD
pages 66 – 73

James Toogood has always been interested in painting the multiplicity of contemporary life, so he pursued formal art training at the prestigious Pennsylvania Academy of the Fine Arts in Philadelphia. His work has since been exhibited widely in more than 30 solo exhibitions in the United States and abroad, as well as many juried group exhibitions, including those of the American Watercolor Society and the National Academy of Design. In addition to having his work shown at many museums — including the Butler Institute of American Art and the Pennsylvania Academy of the Fine Arts — James had his first museum

retrospective at the Woodmere Art Museum in 1986.

Throughout the years, James has been active in and won numerous awards from various American institutions and societies, and has earned signature status with quite a number of art organizations, including the American Watercolor Society, the Pennsylvania Academy of the Fine Arts Fellowship, the New Jersey Watercolor Society and the Northeast Watercolor Society. His work is represented in public and private collections throughout North America and abroad, and has also been featured in several books, such as *Selections from the Permanent Collection, Woodmere Museum*, *Best of Watercolor 2*, *Painting Light and Shadow* and *Splash 6 and 7*.

James is currently represented by Rosenfeld Gallery in Philadelphia, Pennsylvania, and by Windjammer Gallery in Hamilton, Bermuda. He teaches at the Somerset Art Association in Bedminster, New Jersey, and at the Perkins Center for the Arts in Moorestown, New Jersey, both of which are close to his home and studio in Cherry Hill, New Jersey.

XIAOGANG ZHU
pages 100 – 107

Xiaogang Zhu was born and raised in the People's Republic of China. Although drawing and painting has always been his first interest since childhood, he did not start to receive formal academic training at the Su Zhou Institute of Silk Technologies until the mid 70s, after he completed his military service begun at age 14. Ironically, he had the opportunity to develop his artistic talents during the Cultural Revolution because the

restrictive national college entrance exam happened to be banned during those years when he was in training.

Zhu became a textile and graphic designer, then an art professor, both at a vocational school in Nan Jing and at Shanghai Jiao Tong University in China prior to coming to the US in 1989. He earned his Master's Degree in painting at Radford University, Virginia, in 1991. The artist now lives with his wife and two sons in Shelton, Washington.

Zhu paints mostly landscapes and works primarily with gouache. He is a signature member of the American Watercolor Society and has won numerous awards in international art competitions, including the High Winds Medal of the American Watercolor Society in 1995 and a First Place in the Landscape category in 1999. His work has been featured in numerous articles.

His paintings have been exhibited with the Artists of America, the American Watercolor Society Annual Exhibition, the Las Vegas Art Auction and the C.M. Russell Art Auction. The following prestigious galleries regularly exhibit his work: Settlers West in Tucson, Arizona; Trailside Galleries in Jackson, Wyoming, and Scottsdale, Arizona; and Nedra Matteucci Gallery in Santa Fe, New Mexico.

ACKNOWLEDGMENT
We would like to thank the following artists who contributed to the special essay by Betsy Dillard Stroud (pages 60 – 65): Lynn McLain, Albuquerque, New Mexico; Gerald Brommer, Studio City, California; Deloyht-Arendt, Scottsdale, Arizona; Stephen Quiller, Creede, Colorado; Ed Mell, Phoenix, Arizona; Jean Sampson, Charlottesville, Virginia; and William B (Skip) Lawrence, Mt Airy, Maryland.